TRUMPINGTON
THROUGH TIME
Shirley & Stephen Brown

AMBERLEY PUBLISHING

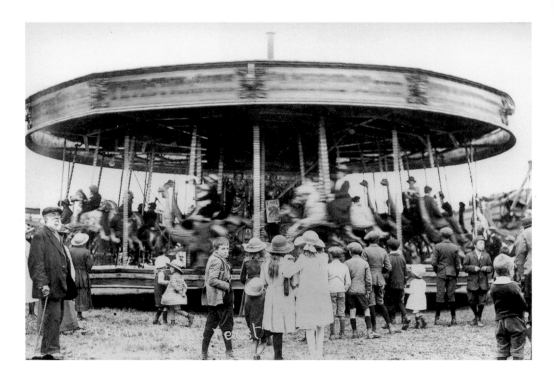

Trumpington Feast, 1920s.

First published 2013

Amberley Publishing
The Hill, Stroud, Gloucestershire, GL5 4EP
www.amberley-books.com

Copyright © Shirley & Stephen Brown, 2013

The right of Shirley & Stephen Brown to be identified as
the Authors of this work has been asserted in accordance
with the Copyrights, Designs and Patents Act 1988.

ISBN 978 1 4456 0633 0

British Library Cataloguing in Publication Data.
A catalogue record for this book is available from the
British Library.

Typesetting by Amberley Publishing.
Printed in Great Britain.

Introduction

Thousands of years ago, dinosaurs wandered freely through the swamps, leaving behind their dung, which would form coprolites, used in the nineteenth and twentieth centuries to produce fertiliser and explosives. Long before Cambridge became important, Trumpington was a thriving community with evidence of Iron Age, Roman and Anglo-Saxon settlements. Manors of Trumpington are listed in the Domesday Book, and Trumpington was noted for its vineyards in the thirteenth and fourteenth centuries. For hundreds of years, Trumpington was an independent village with its parish council and established parish church. It was with dismay when, in 1912, in spite of spirited opposition, the boundary with Cambridge was moved from Brooklands Avenue to Long Road, decreasing the number of dwellings in Trumpington from 304 to 198.

Perhaps the greatest beneficiary was the landlord of The Volunteer, who would be allowed to stay open an extra hour by his 'move' to Cambridge.

The move does not appear to have changed the lives of the majority of villagers. Shepherds still stayed out all night for lambing and harvesting carried on until darkness fell. For the many laundresses in the parish the washing dried at the same pace. And children still stayed at the village school until they reached the legal leaving age of thirteen years.

The First World War had a much greater impact, with 125 men called into service. Thirty-six lost their lives and one man died from his wounds soon after the war ended. Post-war there were still shortages, but by the twenties life was almost back to normal.

Children in those days wandered freely without adult supervision. They would be out all day with their mates, and a bottle of water and a pack of sandwiches (most likely bread and jam). They could fish in the streams, hunt for birds' eggs, pick blackberries, chase and kill rabbits

for a tasty pie and help with harvests. They celebrated many of the forgotten festivals such as Oak Apple Day, Mayday and Empire Day.

For adults, much of the entertainment was home-made: concerts and dances in the village hall, plays produced by local groups and cricket, football or tennis on Saturdays, with refreshments from Noble's Hut.

In 1934, Cambridge swallowed up the remainder of the village and at the age of eleven children had to move to a secondary school in Cambridge. Library books were still issued on Wednesday evenings in the schoolroom but were now from the city library instead of the county library. 1937 saw glorious celebrations for the Coronation of George VI. Alas, all too soon came the Second World War and evacuees from Muswell Hill arrived. They were welcomed into local families but schooled separately in the village hall. Many lifelong friendships resulted.

After the war, the village doubled in size with the large new estate of council houses (many now owner occupied). The Fawcett Schools followed and smaller private developments were completed. There are of course some advantages to being part of the city but most of the time we still feel like a village (there are some people who still refuse to acknowledge that we are living in Cambridge). Currently, whether village or city, we are expanding rapidly with an expected tripling of available housing. There has been much discussion on the naming of the new developments. The former Plant Breeding Institute (later Unilever, then Monsanto) is now Trumpington Meadows – a very acceptable name. The developers of Clay Farm and Glebe Farm have named their area Great Kneighton as a marketing unit with no idea of the final nomenclature. Present inhabitants continue referring to them by their old names.

A few years ago, Royal Mail informed us that since the introduction of postcodes the name Trumpington was superfluous and would be removed from the postal address. Angry letters and a petition persuaded them to drop the proposition.

Boundary with Cambridge

The ford marked the boundary between Cambridge and Trumpington. It was seen as a valuable resource for washing animals. It was kept clean by the inhabitants of Cambridge and Trumpington, and woe betide them if the ford was silted up and unable to run smoothly. Below, the boundary (until 1912), referred to as Stone Bridge, in deference to the ancient milestone.

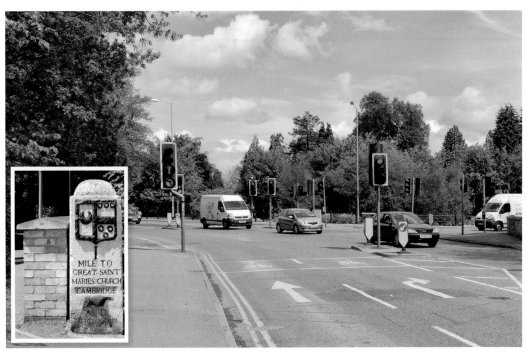

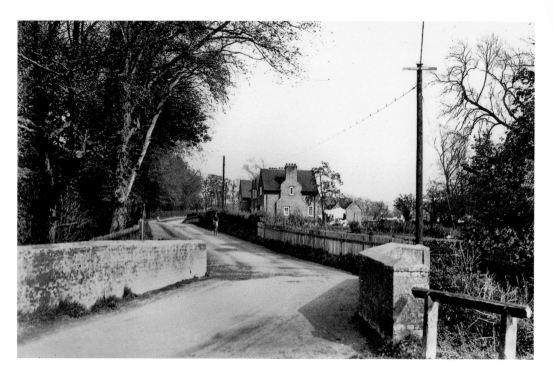

Boundary with Grantchester

The River Cam is the boundary between Grantchester and Trumpington, and is crossed by the Brazely Bridge. Originally, the crossing was a ford slightly downstream from the current location; the first bridge was a simple wooden structure, followed by a picturesque bridge in 1790, which was eventually rebuilt to take motor traffic in 1952.

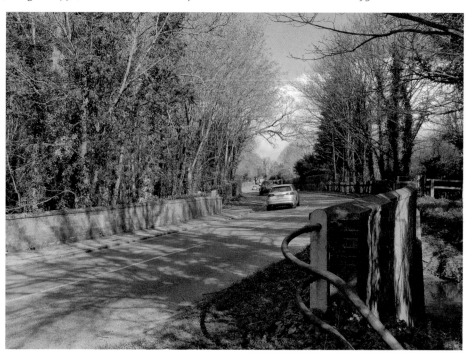

Village Sign

In 1987, thanks to Councillor Betty Suckling's initiative, Trumpington's village sign was erected. It was designed by Philip Jordan and crafted by Stephen Harris. Sadly, it deteriorated, and in 1997 was repainted by Peter Dawson (pictured). By 2009, the sign was in a parlous state and it was decided to have a new sign made in a more durable material. It was designed by Sheila Betts, funded by donations and construction was arranged by Antony Pemberton and unveiled on 15 June 2010.

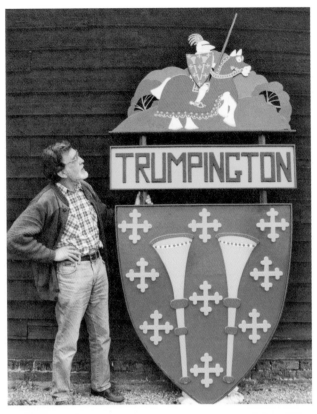

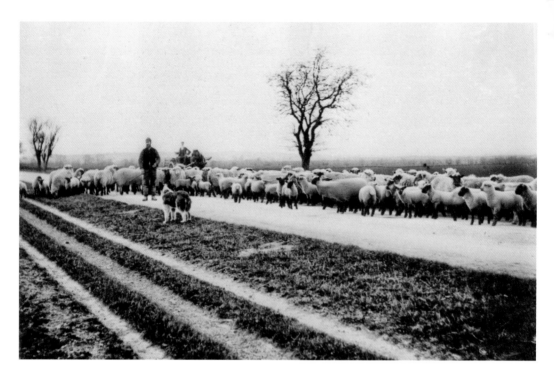

A10/A1309

The main road out of the village heads south to London. It is much busier now than in 1890, when this photograph was taken. We can only wonder if the sheep were on their way to market! When the M11 was built in the late seventies we hoped for less traffic – particularly lorries – through the village. Alas, we now have a constant stream pouring into Cambridge.

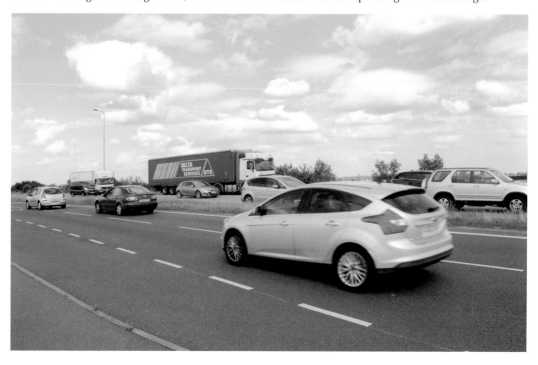

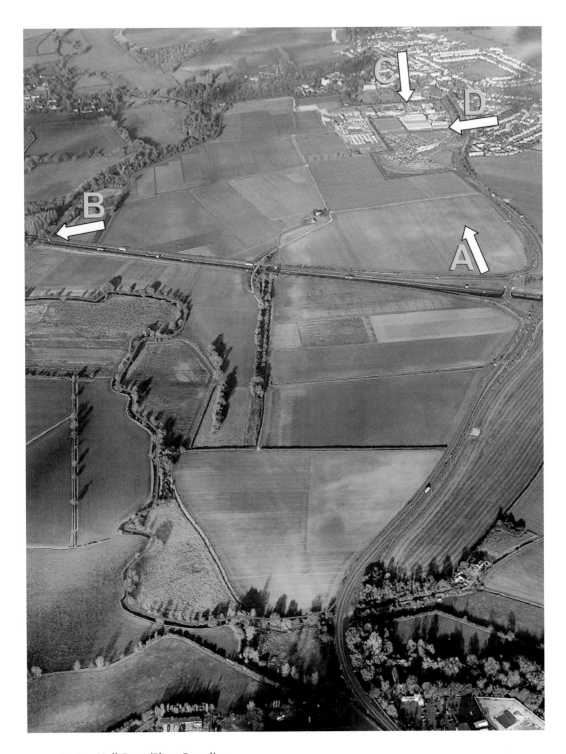

Anstey Hall Farm/Plant Breeding

This aerial photograph shows the outline of the land acquired by the development company Trumpington Meadows that formed most of the area used for Plant Breeding. The four letters indicate the position and direction of the images in the following four pages.

9

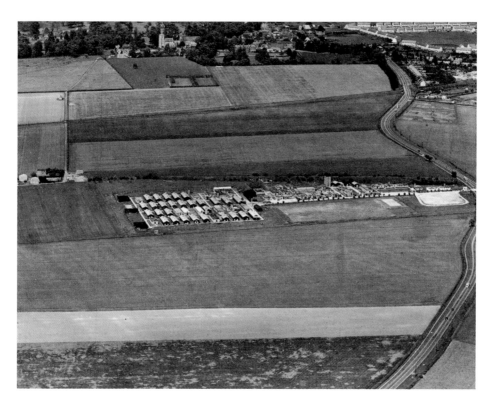

Anstey Hall Farm A

During the Second World War, a prisoner-of-war camp was constructed and gave rise to the name Camp Field. At this stage the remainder of the site was farmland. Shepherd's Cottage and the walled kitchen garden, formerly serving Anstey Hall, are clearly visible. In the lower image the land is again used for arable crops, following the demise of the Plant Breeding work; Shepherd's Cottage has been demolished, and the Portakabin marks the site entrance for the Trumpington Meadows housing development.

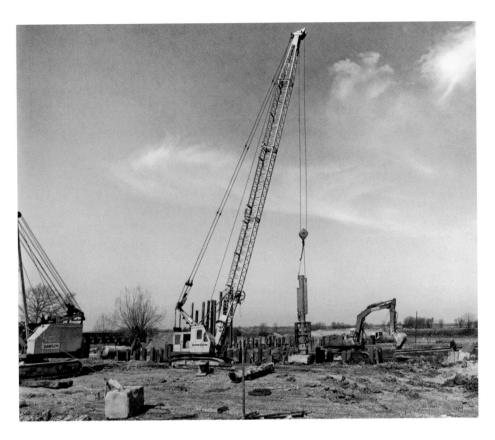

Plant Breeding B

In 1977, construction of the M11 started bisecting the land of the Plant Breeding Institute. The photograph above shows the insertion of piles before construction of the bridge over the River Cam. The photograph below was taken in 2013, showing the bridge, which now carries large volumes of traffic with the resulting noise pollution. It also shows an enormous increase in the number of trees – some planted, while others are from natural regeneration. Similar increases occur in other areas of the parish (*see page 6*).

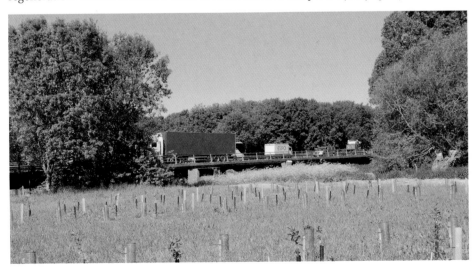

Plant Breeding C

The photograph above shows the main entrance to the Plant Breeding Institute with the raising of the flag following a Queen's Award to Industry, of which four were awarded between 1973 and 1987. Below is the same view in 2013 during the construction of the housing development on the site.

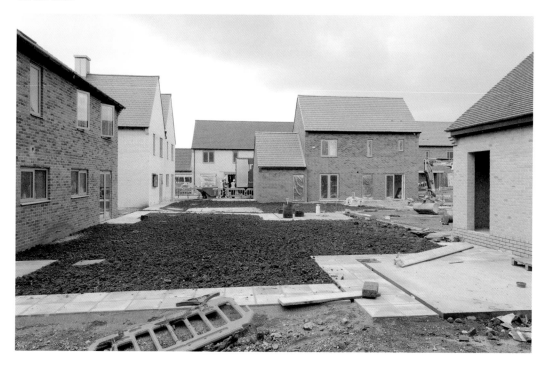

Plant Breeding D

The most changed area in the parish – from sheep to arable farming to plant breeding, intersected by the Cambridge/Bedford Railway line (dismantled in 1968) and interrupted by coprolite extraction in the First World War. By 2008, there was a temporary magistrates' court (foreground), a furniture warehouse (formerly a seed processing facility) and a retail warehouse (background, formerly glasshouses) with its approaching road. In 2013, all had been demolished apart from the retail warehouse and construction of residential housing was well underway.

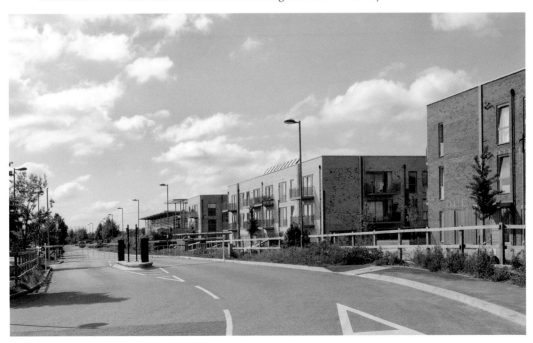

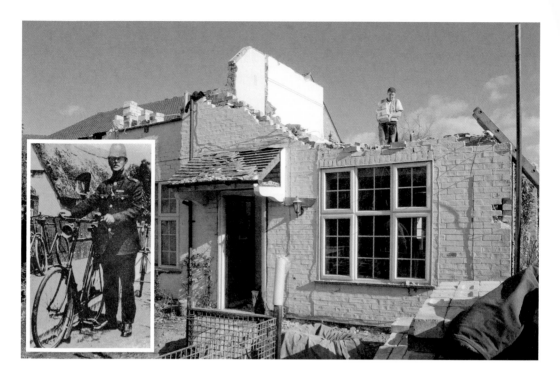

Police House

The police house was built in 1926; the first occupant was PC Pool (pictured). Around 1995, our resident policeman was transferred to Cambridge and in 2010 demolition of the house began. The ground was cleared and this block of flats built.

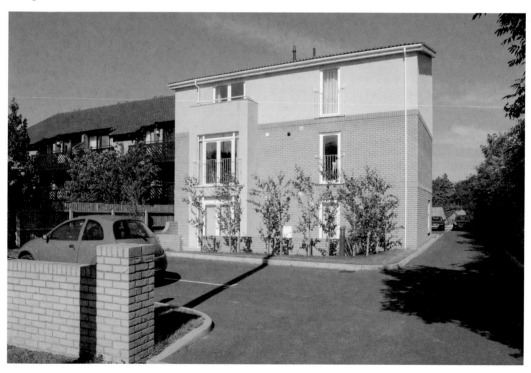

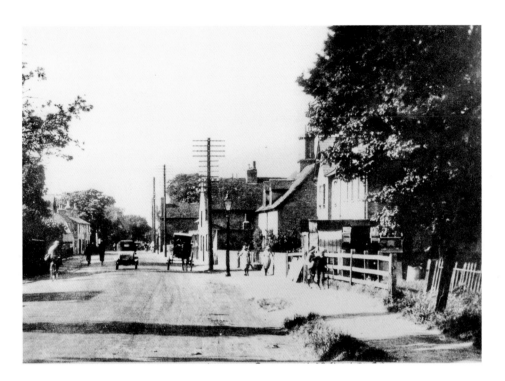

High Street

The Poulter sisters, also known as the wash girls, are heading for the public wash lines beside the cricket pitch. Noble's Hut is on the edge of the pitch selling newspapers, confectionary and, on match days, cups of tea. The grass was cut short by the road, but further back in high summer fielders would be almost invisible, hidden in the long grass. The pleasant area in front of the shops is all that remains of the cricket pitch.

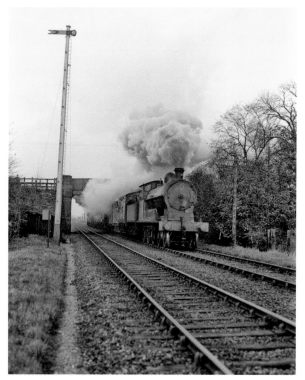

Railway/Guided Bus

Until 1968 trains ran through Trumpington. There was pressure to reopen the line, but eventually the route was used for the much maligned Guided Bus. Running mostly on a special concrete track but where necessary on normal roads the bus takes four minutes to travel from the park-and-ride site to Addenbrookes hospital. It continues via the railway station and Histon to St Ives. The top photograph shows an Experiment class 4-6-0 locomotive on the Bedford line passing under the Long Road bridge in the 1930s. The bottom photograph is the same scene in 2012, where a cycle/footpath tunnel has been constructed beside the Guided Bus route.

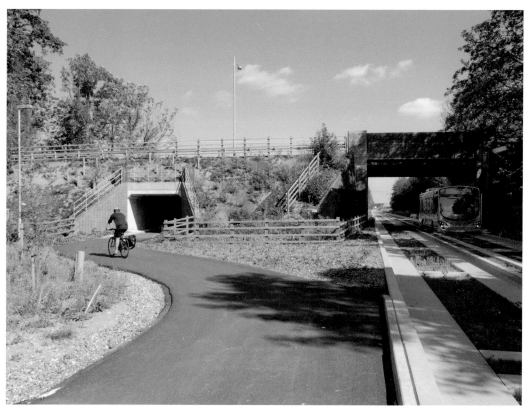

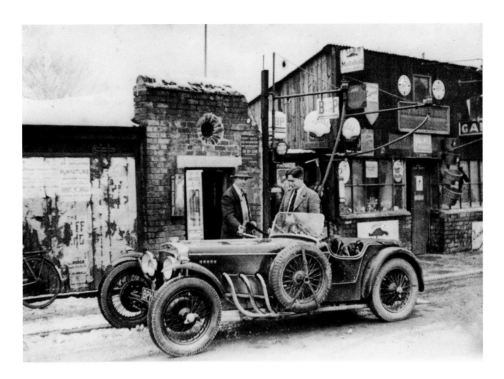

High Street

On the opposite side of the road was the petrol station and cycle repair shop. Of special note in this picture is the old village lock-up (being used as a paraffin store) and the driver – a young (later Sir) Frank Whittle. Now we have the Shell garage with a thriving shop and newspapers for sale.

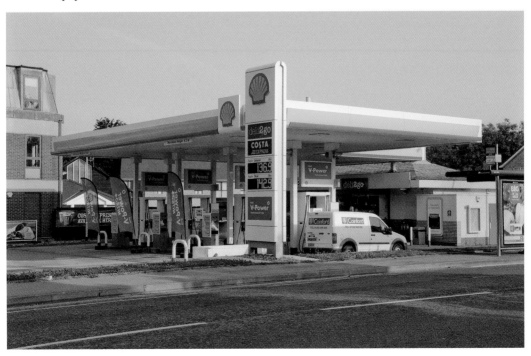

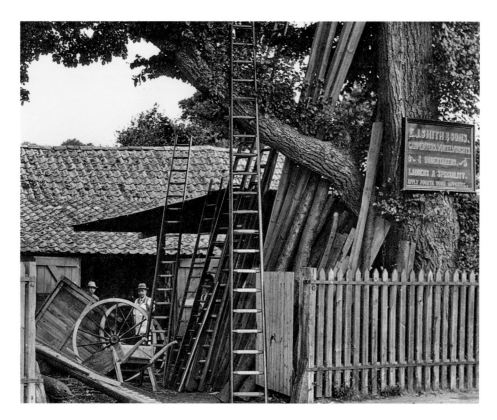

High Street

Smith's Woodyard was a busy place making ladders, gates, wheelbarrows, coffins, fences, carts and, during the First World War, munitions boxes. The Smith 'boys' were renowned cricketers and could be relied on to hit a ball onto the Woodyard Roof. The wine shop and pharmacy/optician's are equally busy and a great asset to the village. In 2005, Jeff Gregory, pharmacist, won 'The Way to Be' award and Noel Young, Wine Merchant, has won several awards for his fine wines.

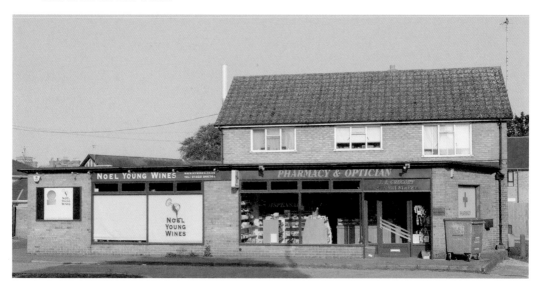

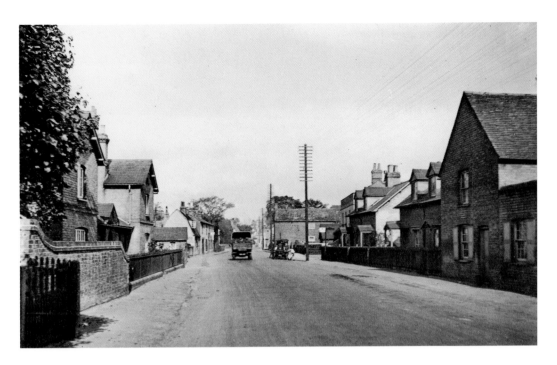

High Street

Left on the 1920s photograph are three almshouses – no longer there. The tall house opposite was the first of seven one-up one-down cottages known as Swan Yard, each with its outhouse opposite. A footpath ran down the side from the High Street. By the 1950s, four cottages had been made into two; some were connected to the main sewer. All tenants could use an adjoining field for linen lines, etc. Now there is one house and a driveway to a large bungalow.

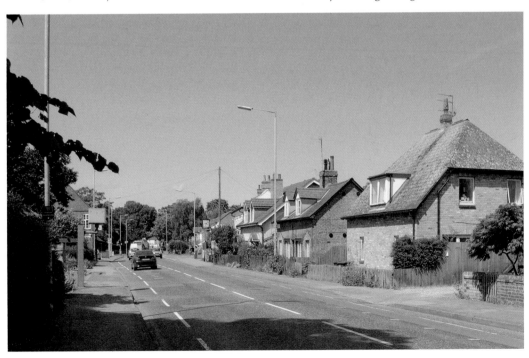

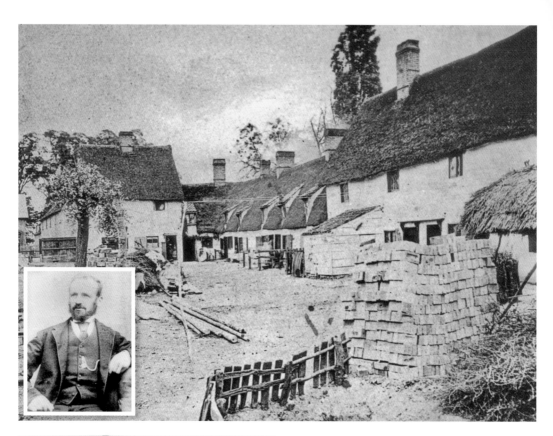

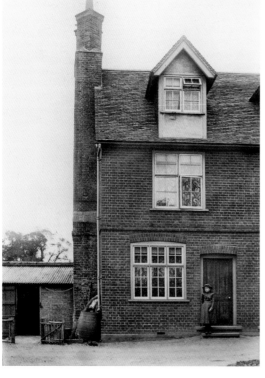

Whitelock's Yard

The above photograph shows Whitelock's Yard in around 1880, with Mr George Careless who lived there. The yard was rebuilt at the end of the nineteenth century. To the left is Vi Wilson's house – one of the larger houses.

Whitelock's to Whitlocks

Whitelock's Yard housed a close and happy community. The biggest drawback was the lack of indoor sanitation. The photograph above shows a toilet/shed block. However, by 1962 the rents that were meant to provide income for the Whitelock Charity were not even sufficient to keep the properties in good repair. So Whitelock's Yard was sold to the city council, the tenants were rehoused, the yard was bulldozed and Whitlocks was built for people over sixty years of age.

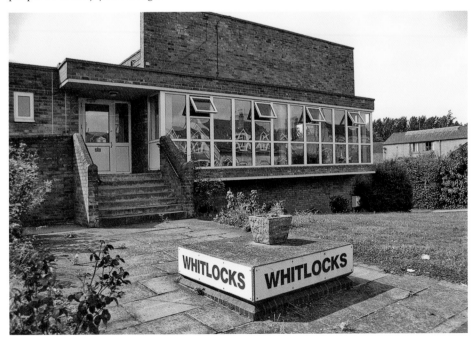

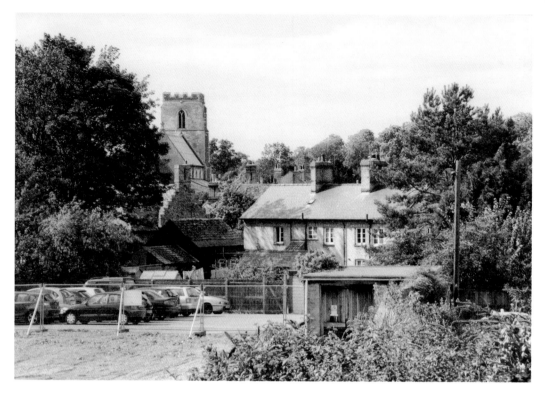

Demolition (or a New View)

Although Whitlock's had a warden and community room, as people's expectations rose they did not want to share bathrooms and by 2004 the rooms were being let to nurses, students and refugees. Whitlocks was then demolished and a new Whitlocks emerged with flats for sale.

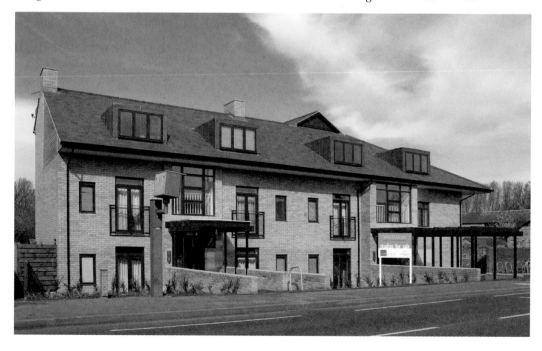

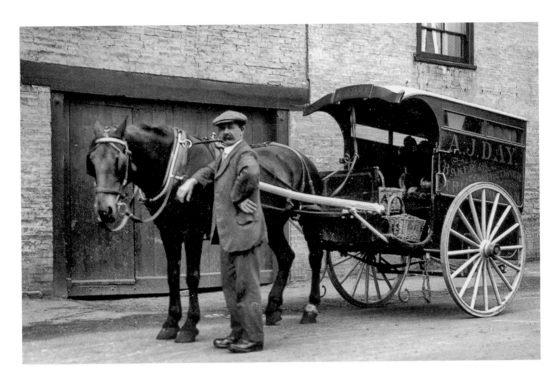

High Street

After Whitelock's Yard and Nos 42–46 (still standing) came this mixed row of shops and cottages. Mr Day, the baker, is seen here with his horse and delivery van. In the 1930s Mr Day knocked down three of the cottages and built a fine grocery store that was later taken over by the Co-operative Society. Currently it is a model shop with a very good reputation and a loyal clientele.

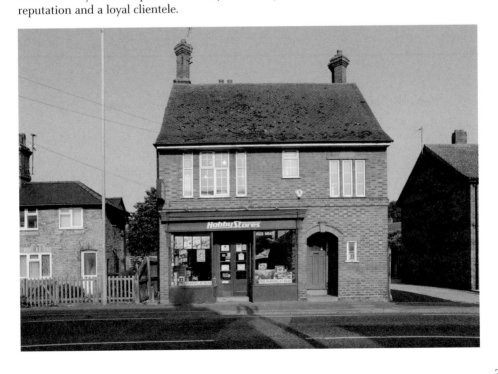

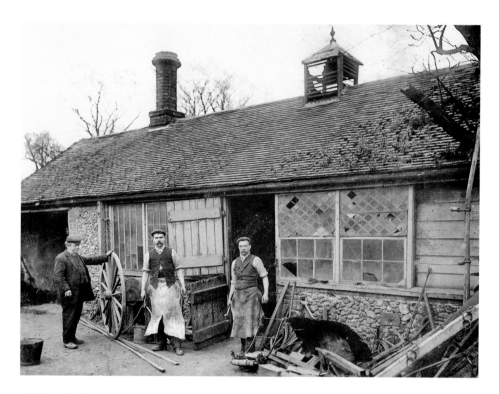

A Piece of History Gone

The smithy was a busy place, employing a minimum of two blacksmiths plus an apprentice. It moved to this site on the High Street in around 1855. Hanging scythes in the open when not in use (see extreme right of photograph) was common practice particularly in winter. It was believed that wet weather rusted the iron out leaving steel. In fact the process of rusting left a slightly jagged edge to the blade that initially cut better than when it was last used in the previous season. Gradually, mechanisation made horses redundant and, by 1967, the Smithy was left to Donald Ramsey, a furniture restorer. In 1985, after much campaigning and protest meetings, the Smithy was demolished – only the flint wall remains of this piece of history. The replacement is shown below.

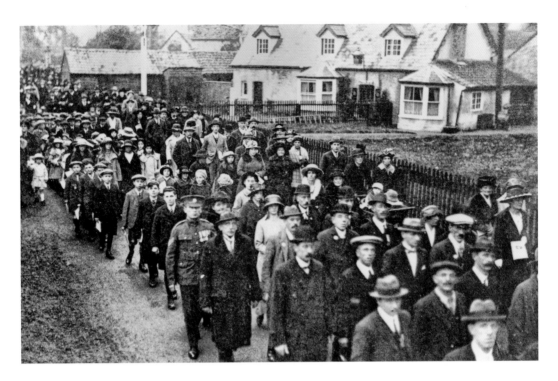

War Memorial

The ceremony of unveiling and dedication of the war memorial took place on Sunday 11 December 1921. After a service in church, the people proceeded to the memorial led by the Cambridge Town Silver Band. All were told their position in the procession and at the memorial. In the lower photograph, the Lord Lieutenant of Cambridgeshire is about to unveil the memorial.

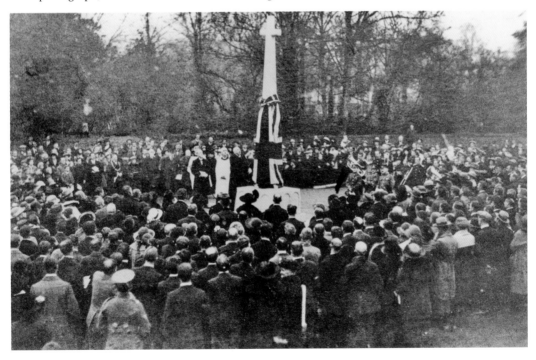

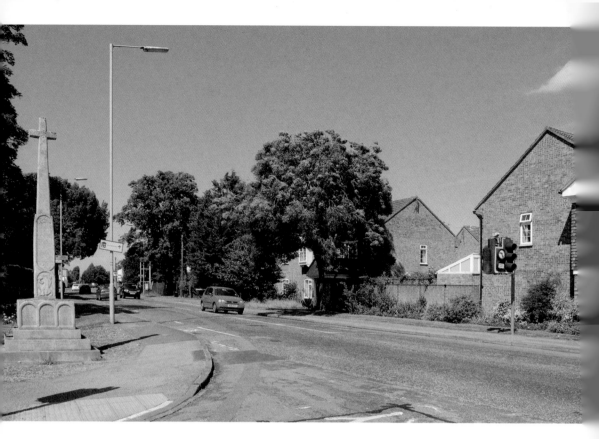

View from Memorial

Looking north in 2013, we have a pleasant suburban view with modern houses and mature trees. When the memorial was erected, the view to the north focused on the Red Lion and the Haslops' Cottage (bottom left). By the 1960s there was a smarter, larger Red Lion (bottom right) standing further back from the road, and affording us a view of Lyme Cottage, remembered as the post office in the 1940s, 1950s and 1960s.

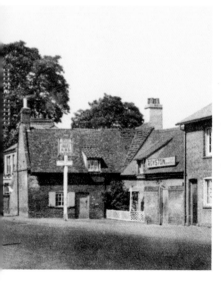

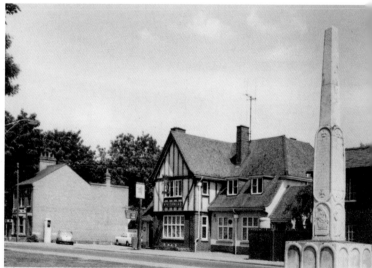

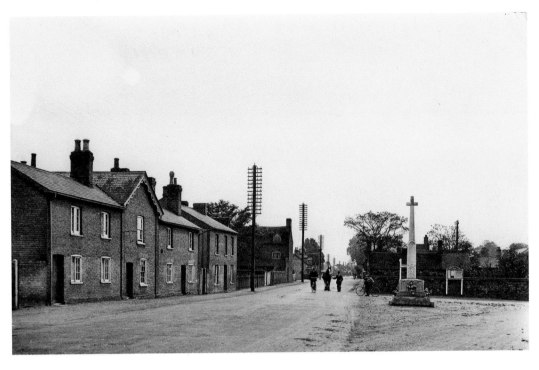

View from Memorial

Another 1920s view of the High Street. All these properties have gone. The tall building in the middle of the photograph is Manor Farm and it is screening the village hall from our view. The village noticeboard is against the Smithy wall, seen below in 2013.

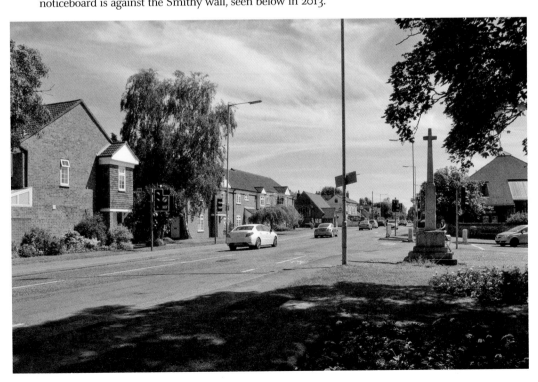

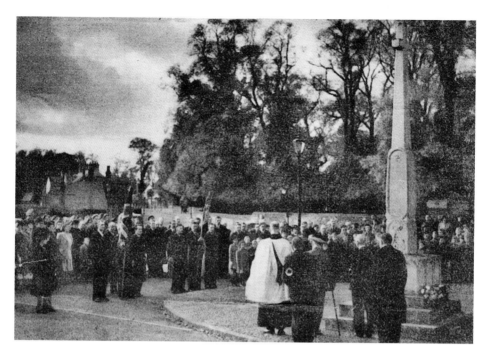

Memorial, 1947 & 2012

In 1947, the names of those killed in the Second World War were unveiled. The service at the memorial every Remembrance Sunday continues to be well-supported, with many people attending the service in church and walking to the memorial to join those already gathered. The lower photograph dates from November 2012.

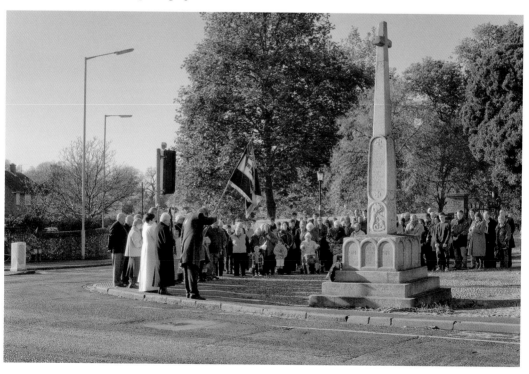

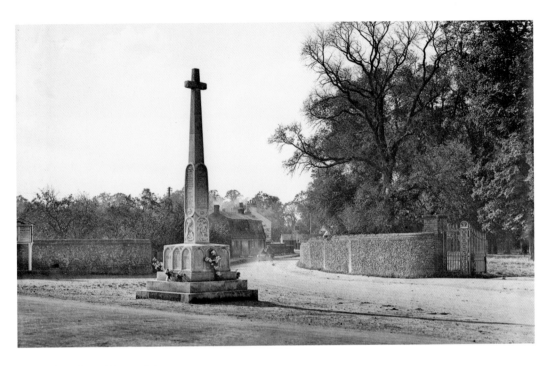

View from Memorial

The final picture of the memorial looks into Church Lane when it continued behind the memorial to join the High Street. In 1938, the main sewer was laid under that road and Church Lane was rerouted to join the High Street between the Smithy wall and the memorial. This allowed for an area of grass around the memorial and a memorial flower garden.

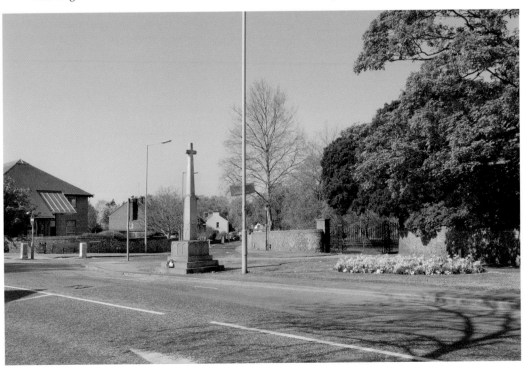

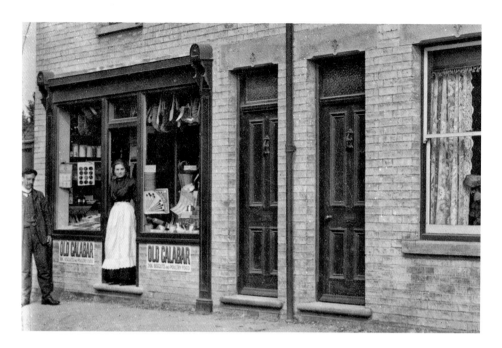

Church Lane

Looking at the previous pictures, you can pick out three cottages close to the road. Beyond them two substantial houses were built by George Lowe in 1901. George and his wife lived in No. 14, and No. 15 was for some years home to the village bobby. In 1906, William and Hannah Lowe moved into No. 14 and Hannah (seen in the shop entrance) set up a front room shop. In the mid-nineteenth century, between the cottages and No. 14, there was a tumbledown cottage nicknamed Buggingham Palace, the home of Trumpington's witch, Susannah Saville. For a piece of silver she would guarantee trouble for your enemy by giving roup to his chickens, glanders to cattle, fever to pigs and creeping palsy to his wife.

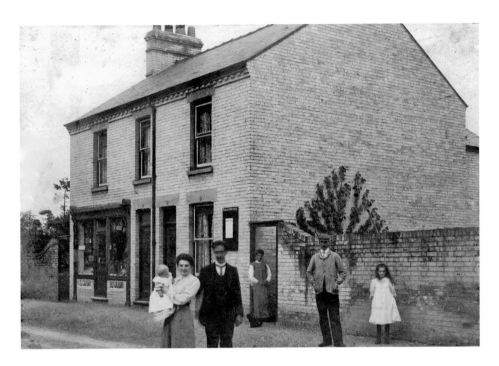

Church Lane

William and Hannah with their first baby (Ellis) born in 1907. I think the tall man in the background is PC Pallant who lived in No. 15. Hannah's shop is listed in the 1911 census. I am guessing that it closed when the First World War began. By 1918, Hannah's sister Nellie and husband Alf Burbridge were living in No. 15 and built No. 16, where they were renowned for the excellence of their fish and chips.

Church Lane

In addition to the fish and chips, Alf had a round selling wet fish. During the Second World War, fish was a very popular food as it was not rationed. Sadly, Alf died in 1940 and Nellie carried on the fish and chips with the help of her unmarried sister Agnes. No. 16 now looks very neglected; it has been home to various businesses. Below, the Unicorn stables used by many traders (including fish and chips) are visible.

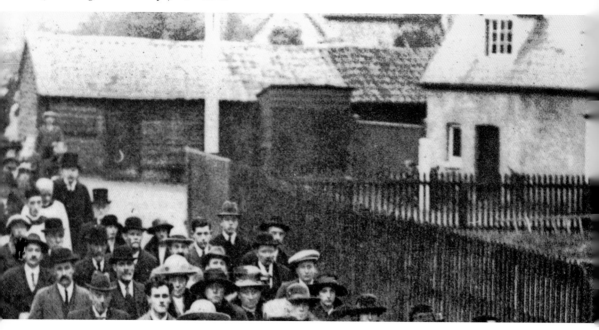

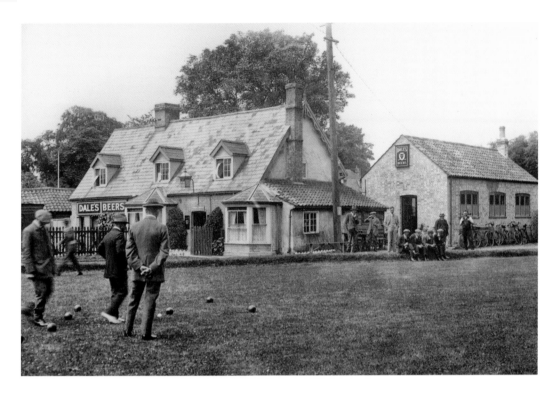

Church Lane

The Unicorn, built in 1858 as a beerhouse, was a haven for 'working men' – there was beer and darts in the pub, fish and chips in the stables, and a bowling green, plus all-male outings! Alas those halcyon days are gone; the bowling green is a car park, an extension encourages overnight guests and the last venture in the stables was decorated cakes. To cap it all, the name is now The Lord Byron. (Personally I think it is an improvement.)

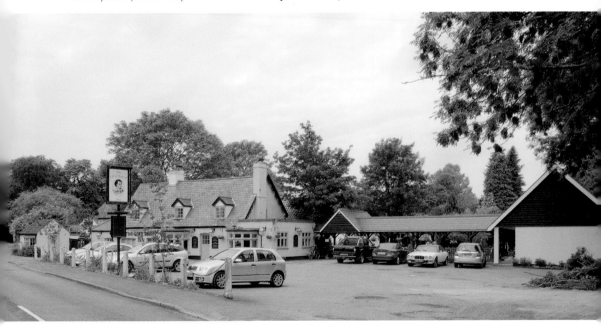

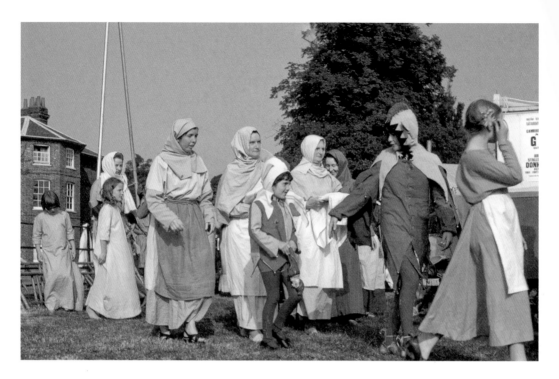

Grantchester Road

The beautiful and extensive grounds of Trumpington Hall have frequently been used for church and village events. The top photograph was taken in 1970 when a pageant celebrated Sir Roger going off to the Crusades in 1270. The lower photograph shows the Cambridge Brass Band giving a magnificent performance in 2008 during celebrations of the centenary of the Village Hall.

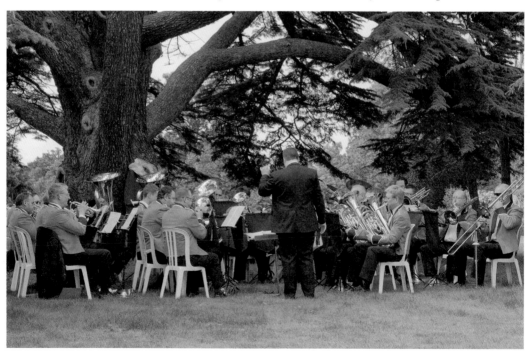

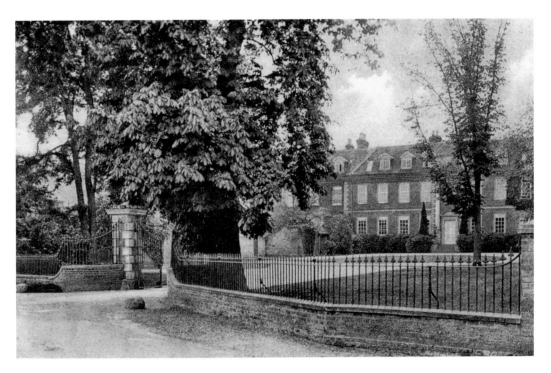

Anstey Hall

This was the old entrance to Anstey Hall. The new entrance shown below was built early in the twentieth century when Mr Foster bought a substantial portion of land from the vicar. The new entrance and a site in front of Trumpington Hall gates were contenders for the position of the war memorial.

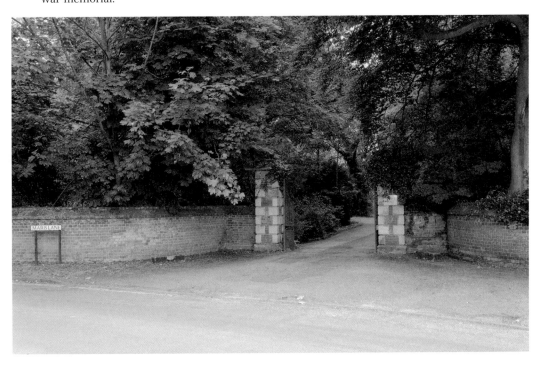

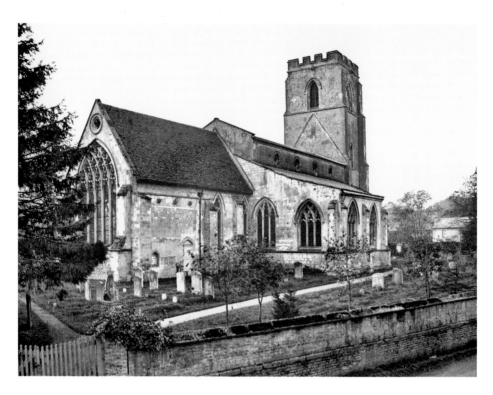

Parish Church of St Mary & St Michael

Comparing these two photographs you can see by the outlines on the tower that the nave has had at least three roofs. The 1860s photograph is taken from a glass negative made by Samuel Page Widnall and found in a garden shed by John Lester of Grantchester. John kindly lent us the negative and Stephen edited out the cracks and dirt in the emulsion to produce this picture. The modern photograph was taken in 2008 for the Village Hall Centenary Exhibition.

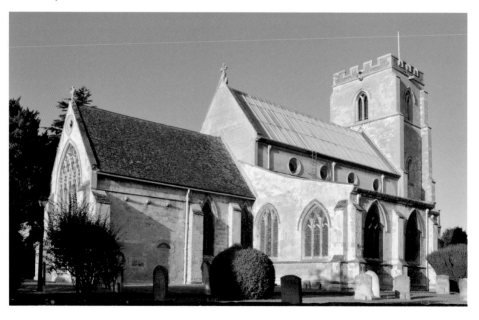

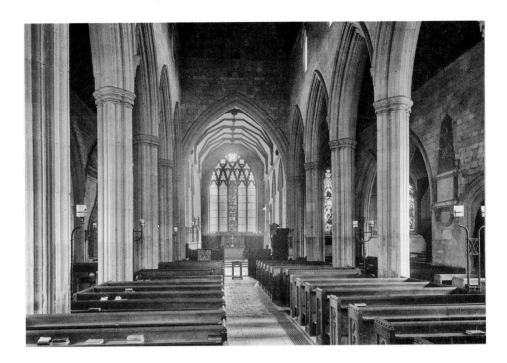

Church Interior

The 1920s photograph shows the old gas lights, replaced in 1934 with electric lights on pendants crafted by village blacksmith Elijah Lawrence. Other alterations include organ transfer from the South Chapel to high at the back, under the tower, with a small altar replacing it in the Children's Corner. The east window has been reglazed, and the pulpit moved across the aisle and replaced by a lectern. Several pews have been removed, affording better access.

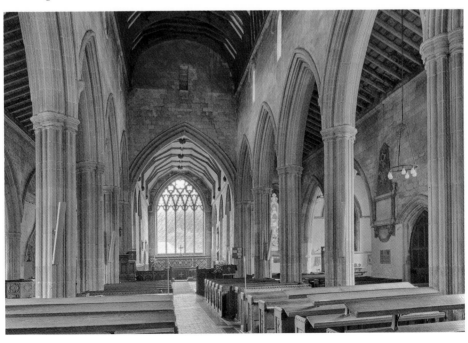

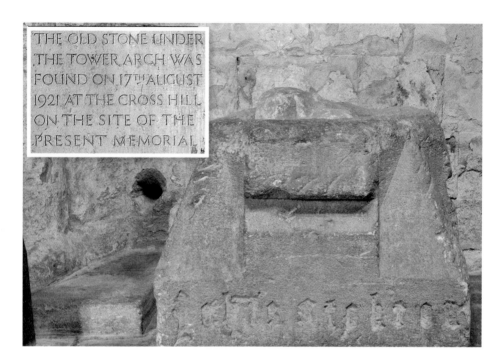

Village Cross

When workmen started digging the site for the war memorial, they found the base of the old village cross. This is now kept under the organ loft in the church. The remains of the shaft that held the wooden cross is in the graveyard, where in at least three churchyard surveys it has been described as a broken unnamed grave.

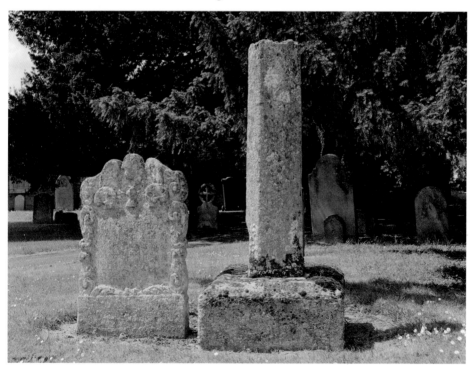

Parish Church

In the late 1960s, Mrs Margaret Gardner designed a set of kneelers based on heraldry. They celebrated the septcentenary of Sir Roger de Trumpington heading east in 1270. Since then, two further sets have been designed by Mrs Kathleen Eeles and Dr Clare Bartlett. Local ladies (and the occasional man) have stitched the kneelers. There are many additional kneelers – some in remembrance of loved ones; others gifted. They make up a truly wonderful collection.

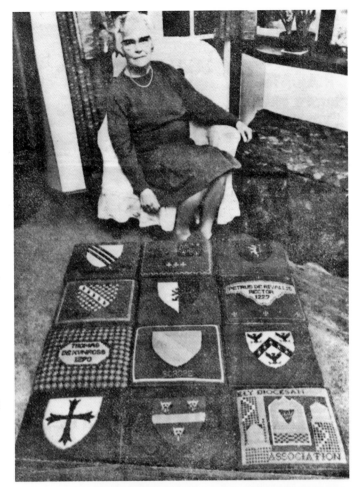

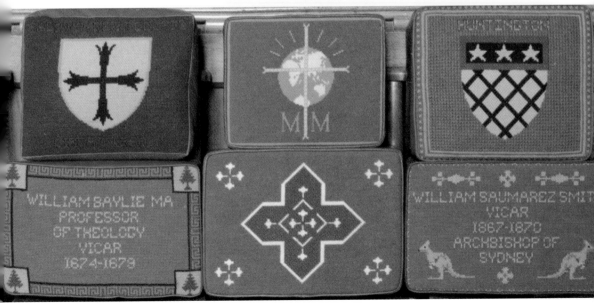

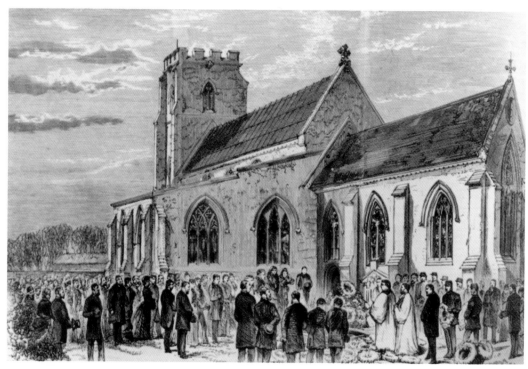

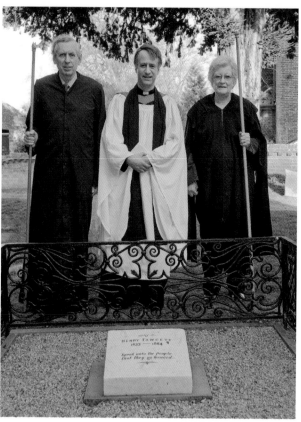

Graveyard

Henry Fawcett, first professor of Political Economy at Cambridge and Postmaster General (responsible for introducing the parcel post), was buried in Trumpington churchyard in 1884. In 2004, the local history group campaigned successfully for a blue plaque on his house and in 2008 restored his grave. A rededication service was conducted by the Dean of Trinity Hall, Dr Jeremy Morris.

Graveyard to Cemetery

The graveyard surrounding the church holds many interesting gravestones and monuments. It was reaching capacity in the nineteenth century. A piece of glebe land on the corner of Shelford and Hauxton Roads provided a cemetery that was dedicated in 1893; the first burial was in 1894, but it was not consecrated until 1923. By 1990, the cemetery was almost full: the PCC bought the Vicarage Vegetable Garden for a new graveyard.

New Graveyard

Part of the new graveyard was consecrated in 1991; the remainder followed a few years later. The rules were simple: headstones but no kerbs on graves, and no planting or vases on the cremated remains plot. This was not popular. While mowing said plot, the vicar was approached by an aggrieved parishioner, who asked, 'What would the good Lord Jesus say about not allowing plants and flowers?' Nicholas Thistlethwaite replied, 'The good Lord Jesus doesn't have to mow the grass.'

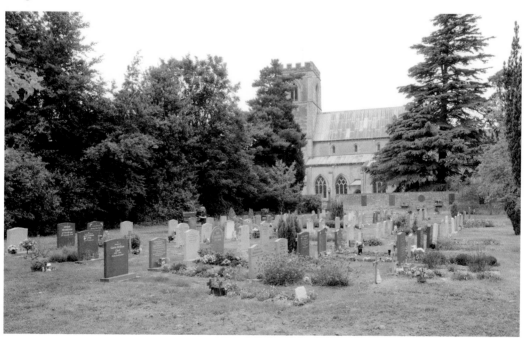

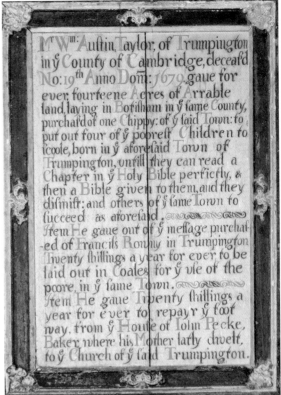

Mr Wm: Auſtin, Taylor, of Trumpington
in ẏ County of Cambridge, deceaſd
No: 19th Anno Dom: 1679. gaue for
ever, fourteene Acres of Arrable
land, laying in Botiſham in ẏ ſame County,
purchaſd of one Chippy: of ẏ ſaid Town: to
put out four of ẏ pooreſt Children to
ſcoole, born in ẏ aforeſaid Town of
Trumpington, vntill they can read a
Chapter in ẏ Holy Bible perfictly, &
then a Bible given to them, and they
diſmiſt: and others of ẏ ſame Town to
ſucceed as aforeſaid.
Item He gaue out of ẏ meſſage purchaſ
-ed of Francis Ronny in Trumpington
Tiventy ſhillings a year for ever to be
laid out in Coales for ẏ vſe of the
poore, in ẏ ſame Town.
Item He gaue Tiventy ſhillings a
year for ever to repayr ẏ foot
way, from ẏ Houſe of Iohn Pecke,
Baker, where his Mother latly dwelt,
to ẏ Church of ẏ ſaid Trumpington.

Trumpington Charity

In 1679, William Austin left money
for poor children to be taught to
read and receive a Bible when they
could read a chapter. Bibles for good
readers continued into the 1980s
when individual gifting from charity
money was outlawed. In 1681, Thomas
Allen left money to provide tools
for apprentices. The Allen, Austin,
Whitelock and several smaller
charities are now combined into the
Trumpington Charity, which gives
grants to Fawcett School and local
groups. In 2010, Brownies were given
money towards coach costs for their
Girl Guiding Centenary Holiday, where
Jess (*right*) is enjoying taking part.

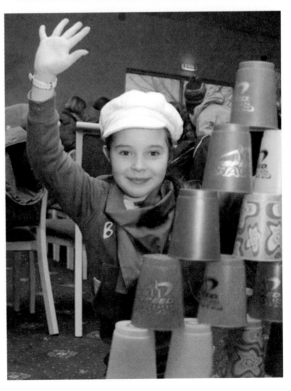

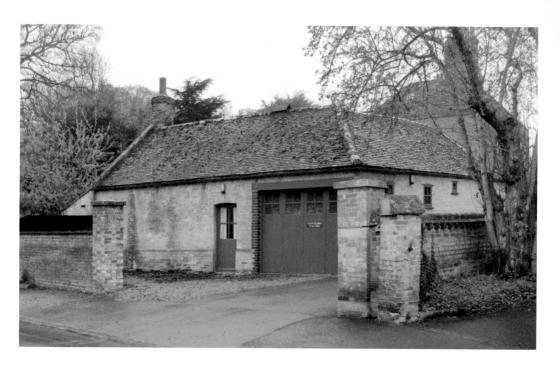

The Bakehouse

The bakehouse (or was it a brewhouse?) and garage belonged to the church and vicarage. The bakehouse was used over years as a meeting place, rehearsal room, Sunday school and extra school classroom. Having lost the use of the old school, the PCC took the decision to turn the building into parish rooms. This was accomplished in 2010.

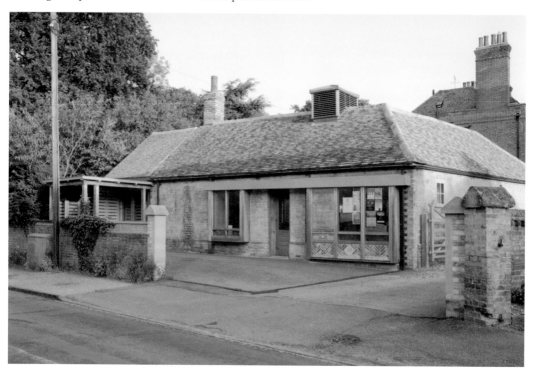

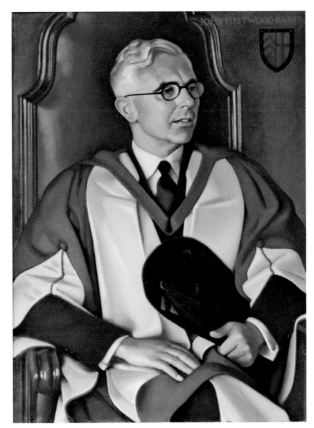

Lord Baker

Lord Baker of Windrush is best known for his Morrison Shelter (pictured), which saved lives during the Second World War and was put to a variety of 'good' uses after the war. In Trumpington church he is remembered for his 'machine to sweep the cobwebs from the church ceiling'. Worked by levers, it was the forerunner of the adjustable brushes available now. He is also remembered for his friendly and courteous manner.

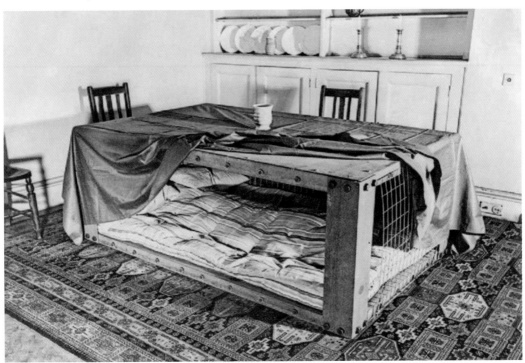

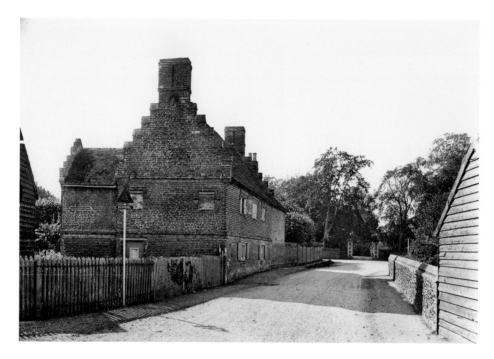

Church Lane

The Old House is said to date back to the sixteenth century. The stepped gables suggest Dutch influence. Soon after the black-and-white photograph was taken (1922), the cottage at the end was knocked down and the house extended. The rather scruffy railings have been replaced by bricks, and a telegraph pole replaces the school sign. The house was almost certainly thatched when first built.

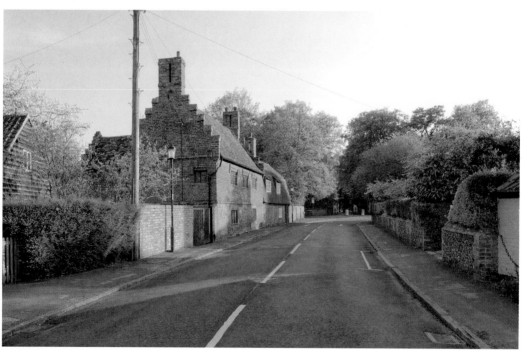

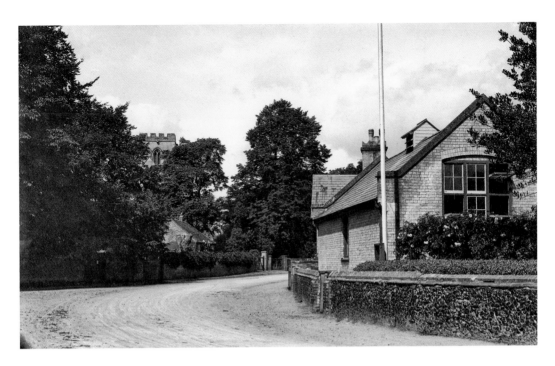

Old School

The national school (more commonly known as the church school) was built in 1842. On the same site was an old thatched cottage that served as the headteacher's house until a house was built next door for him. After the Fawcett School opened the premises were used by the Farm School, and then became the church hall. Since 2005, it has been let to the Rainbow Nursery. The school house is now privately owned.

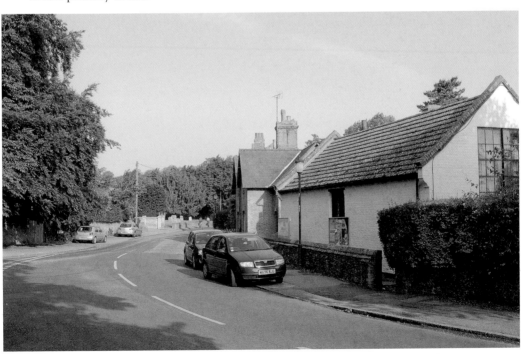

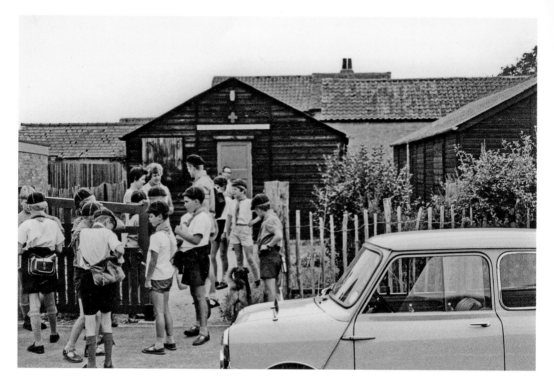

Village Hall

Built in 1908, the front aspect of the village hall appears little different now than when it opened, in spite of many alterations and extensions. However, the back is much changed. For many years there were two huts. One belonged to the Army Cadets, the other to the Scouts. The latter was used by Scouts and Cubs, and occasionally by Guides and Brownies. The (Temporary) Surgery opened in 2002 and is a branch of the Trumpington Street Practice.

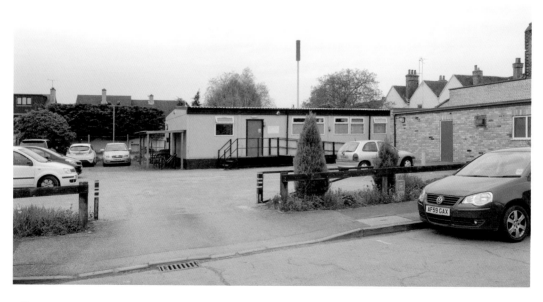

St Mary's

St Mary's, also known as Southery House, was built on the site of Mr Cumming's school – a private boarding/day school for boys, as well as poor children funded from the Austin Charity. When the school closed it was demolished by Scotts' builders and St Mary's was built. For many years the doctor's surgery was held in St Mary's and continued there for some years after Dr Stockley died. It is now 'Home Affairs' with a wide selection of upmarket home furnishings.

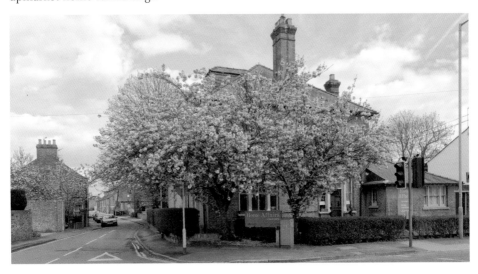

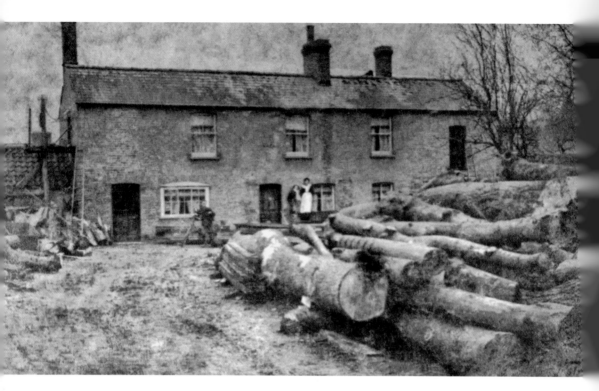

Alpha Terrace

Sheldrick's Sawmill was a noisy neighbour for Mr Todd in St Mary's House, so he took out an injunction to close it down. He then acquired some of the land to enlarge his garden, and part of it was used by the Free Church when they built the schoolroom in 1924. The three Sawmill Cottages that fronted Alpha Terrace remained for several years, numbered 1, 2 and 2a.

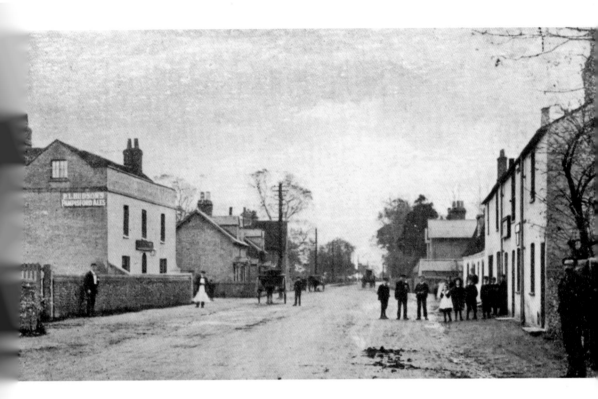

High Street

There are over 100 years between these two scenes. The young people pose happily in the High Street – no worries about traffic – there is no pavement and the road surface is poor. Most of these buildings have gone, but the Tally Ho has had a makeover and the two cottages next to it were extended and renovated in the 1970s.

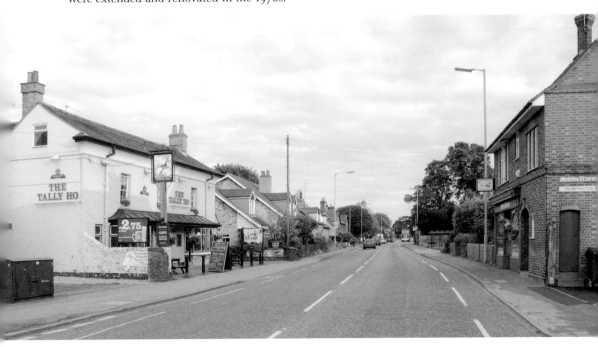

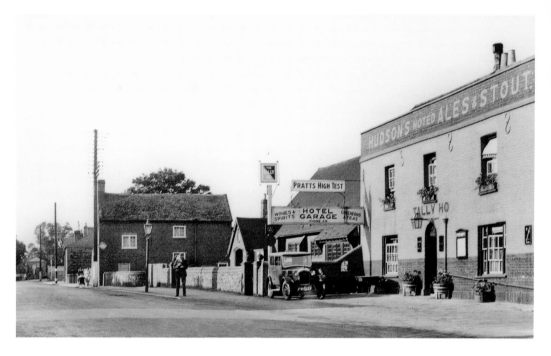

High Street

In 1932 the High Street looks much smarter. The Tally Ho proudly advertises luncheons and teas and offers a garage. The village hall still has its retaining wall, as has Manor Farmhouse. There was a narrow path between them – just wide enough to take the cows on their walk down the High Street. By 2013, the Tally Ho has had structural changes and there are no retaining walls to be seen.

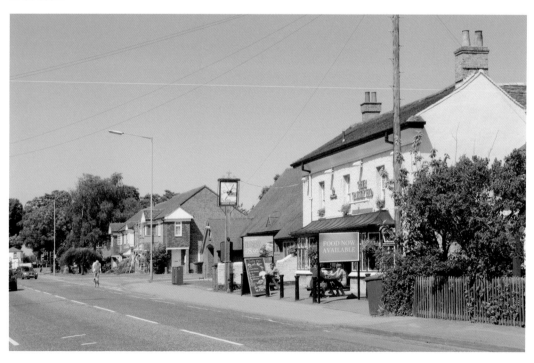

Free Church

Opening in 1899, the Free Church has been a constant force for good in the community. Currently the large congregations meet in the C3 centre and St Bede's School. The chapel houses the church offices and is a hive of industry organising – for example Cambridge Foodbank and breakfasts at Jimmy's Night Shelter. The schoolroom is also in constant use hosting toddler groups, pensioners' coffee mornings and relationship courses.

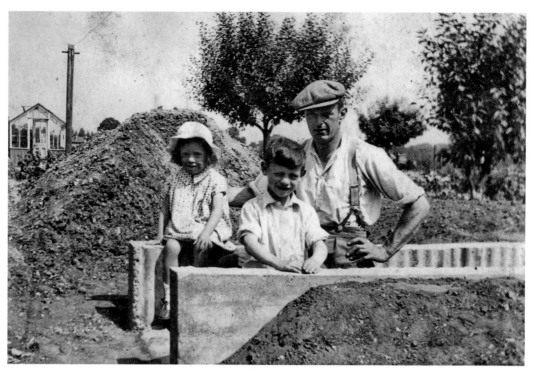

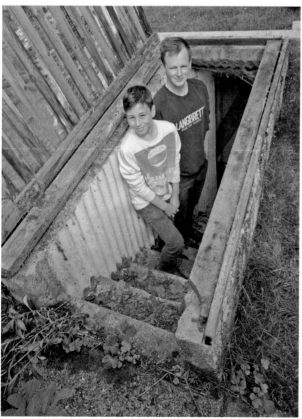

Second World War Air-Raid Shelter

Cecil Galley, with children Ann and John, is building his air-raid shelter in the garden of No. 71 Alpha Terrace. Soil from the excavation was sieved to obtain stones for the concrete. The shelter could accommodate six people. It is now owned by Neil and Sarah Stepney, shown with their sons Charlie and Will.

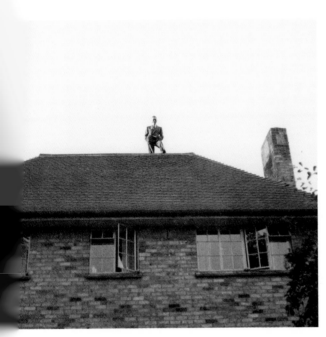
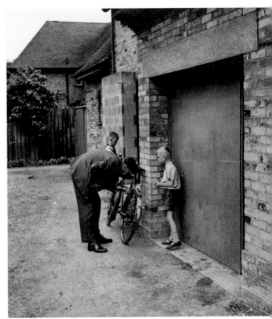

Long Road

Still with the Second World War, and Professor Barnes is fire-watching from the flat part of the roof of his house (Merryland) on Long Road. In the second picture you can see the blast wall in front of a window. It was built of interlocking concrete blocks and the centre was filled with sand. The family slept on the floor of this room during an air raid. In recent years the house has been extended and modified.

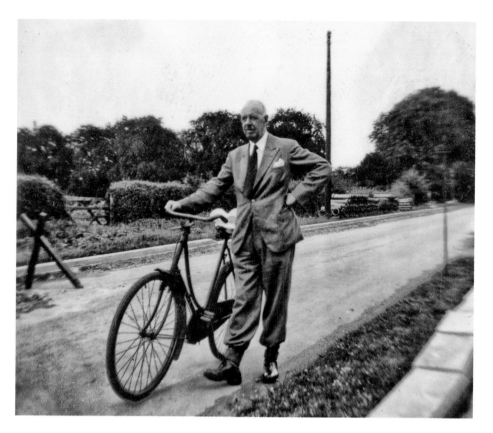

Long Road

Mr Sidney Barrett with his bicycle on Long Road in the late 1940s. In the photograph you can see the kerb stones that would be laid on the edge of the road as part of the upgrade. For a time the road was part of the Cambridge Ring Road; it is now an important A road as seen below.

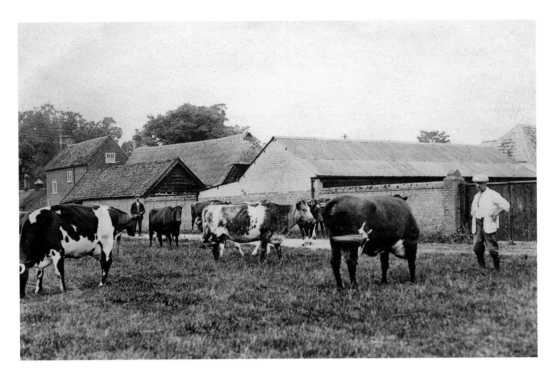

Manor Farm Cows

The Pemberton family owned all the farms in Trumpington apart from Anstey Hall Farm. R. E. Cornwell and his son Reg managed Manor Farm, and in 1931 also took on the tenancy of Clay Farm. The top picture shows Manor Farm in the 1930s and below is its replacement, Beverley Way. The parked cars are typical of many Trumpington residential streets.

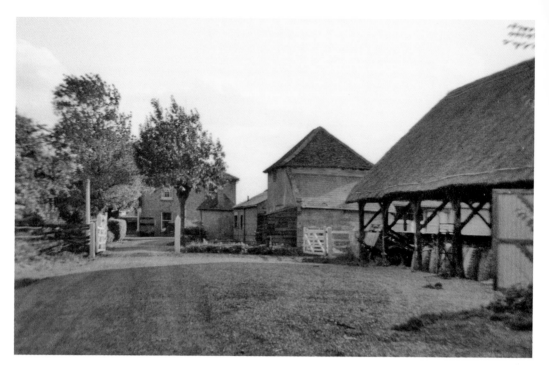

Clay Farm, Long Road

Mr Cornwell Snr died in 1930 but Reg carried on with both farms. During the Second World War, Reg was commended for encouraging parishioners to glean his fields for their hens. The soldiers in the Army camp on Long Road were delighted to be supplied with his fresh milk. Clay Farmhouse is now a private house and other houses are springing up close by.

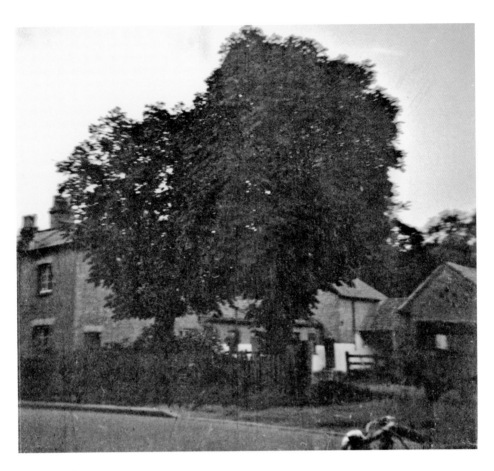

Long Road
Reg Cornwell also took on Trinity Farm, now the Telephone Exchange.

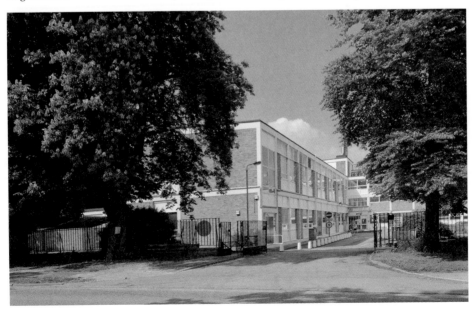

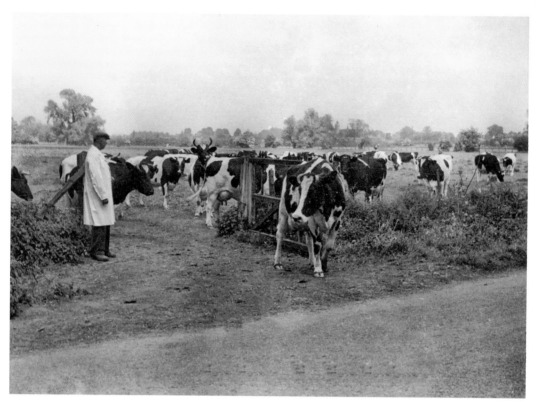

Long Road

Reg rented land along Long Road, notably the 'polo' field pictured above. Now the cows are gone and the houses of Rutherford Road are well established.

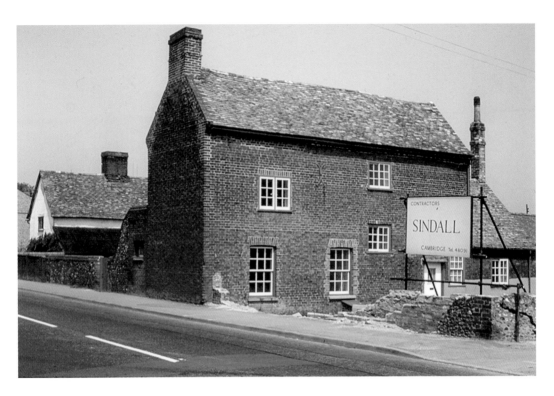

High Street

In 1969, Manor Farmhouse was demolished and Whitbreads were keen to build a sixty-seven-bed motel to service the Green Man and the Red Lion. One building stood in the way of their plans – No. 71 High Street, seen behind Manor Farmhouse (No. 73) in the top picture and behind the farm buildings after the farmhouse had gone in the lower photograph.

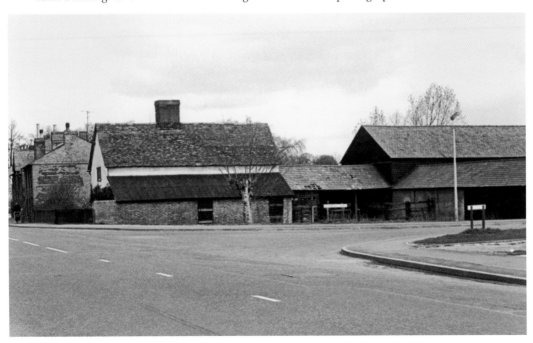

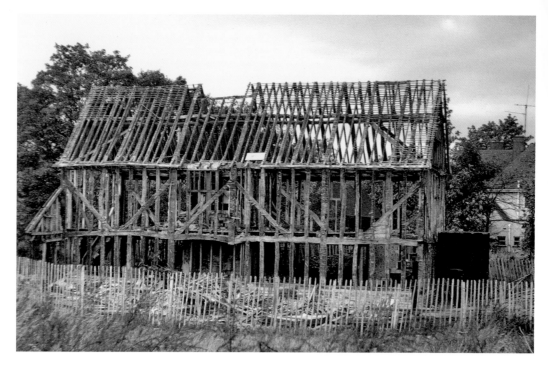

High Street

In 1975, the *Cambridge Evening News* reported on the fight to save Manor Farm, but the building in question was not Manor Farm – it was No. 71, now reduced to its timber frame. Eventually, someone bought the timber frame and it was reportedly reconstructed at an undisclosed location. By then, Whitbreads had lost interest and instead of a motel Trumpington Court was built.

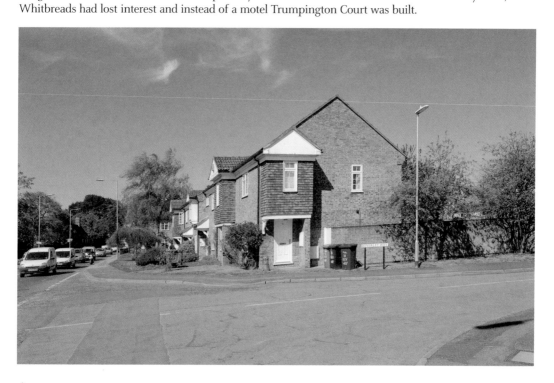

Fawcett School

The Fawcett School opened in 1947. The infant and junior schools were in separate buildings connected by a dining hall (with its own kitchens). The infant school had a spacious nursery for children under five years of age – one of the first state schools to provide specific nursery education. In 1989, the schools were amalgamated into Fawcett Primary School. The junior school was extended and the infant school building became the Cambridge Professional Development Centre.

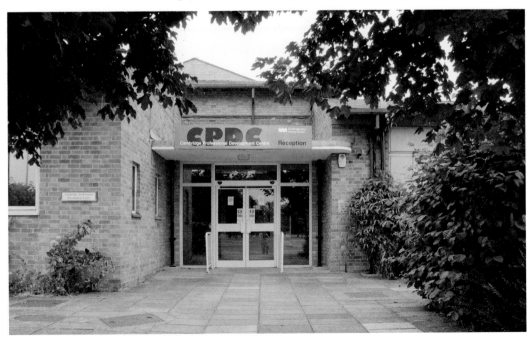

Friendship Club

This club for people over sixty-five started in 1949, with Lady Rotherham at the helm. By December 1950 there were ninety members. The top photograph shows them enjoying their Christmas party in 1952. The late Bert Truelove, his wife Brenda and Mrs Ann Wedd took over the organisation of the club until it closed in the mid-1990s. In 1997, Bert was awarded an MBE.

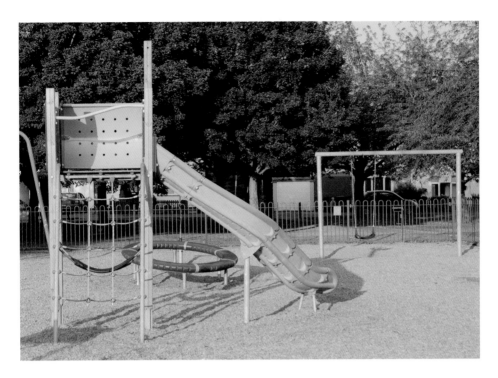

George V Playing Fields

Parents had complained that the playground rides on the George V Playing Fields were old and tatty. In 2004, new equipment very different in style from previous 'rides' was installed and still looks good almost ten years later. However, in 2012, Trumpington was chosen to try out solar-powered equipment. Mayor Councillor Sheila Stewart certainly enjoyed the ride.

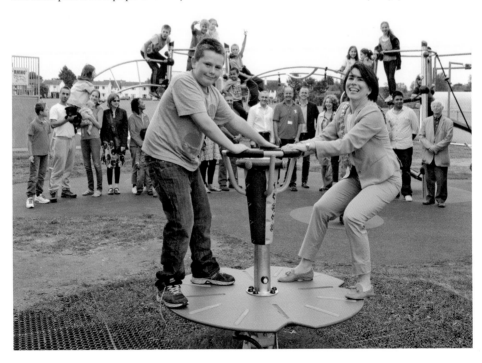

George V Playing Fields

Everyone could see the need for a new pavilion. The old one, shown above, was scruffy, ramshackle and not fit for purpose. It took a long time but in 2009 we finally got our new pavilion, and it is very well used by a large cross-section of residents from babies to pensioners. It is administered by the Residents' Association as a limited company – Andrew Roberts is currently the company secretary.

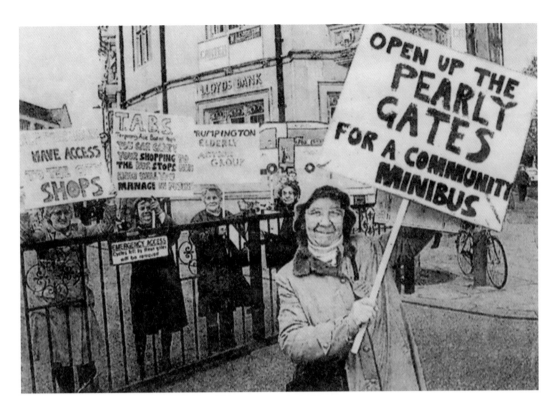

Elderly Action

In 1989, the city council wished to improve the lives of the elderly residents of Trumpington. The Elderly Action Group was formed, encouraging members to express their ideas. The first action was to campaign for a community minibus in the city and the resulting bus that trundled round the city was well used. Sadly, it was axed in 2012, but the group continues to tackle problems, meets regularly and supports the Residents' Association. Below is the New Year Party in 2013.

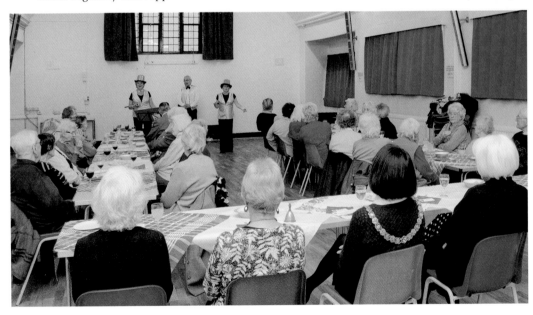

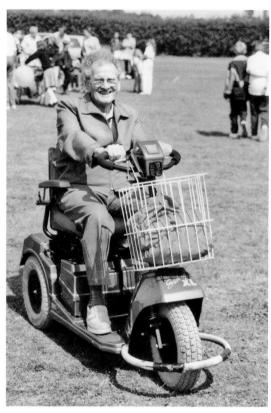

Elderly Action

For several years the Elderly Action Group ran a 'Hire a Scooter' scheme. Some people borrowed the scooter (free of charge) on a regular basis. Others learnt to ride and then bought their own. After several years, scooters became cheaper and more readily available and the scheme closed. The top photograph is the scooter on show at the village fête in 1991. The lower photographs show two of the many current scooter owners.

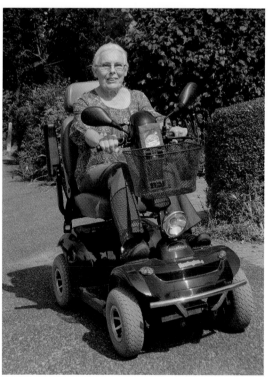

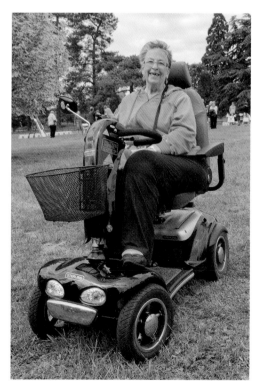

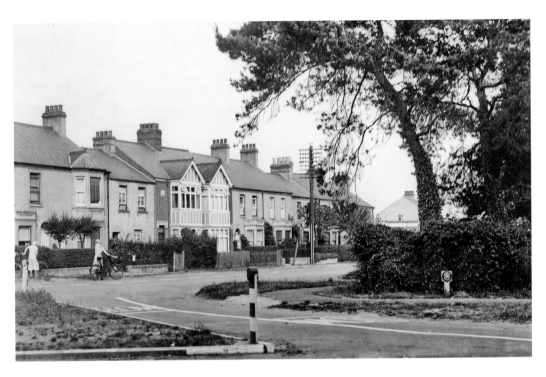

Shelford Road/High Street

This junction has been altered several times and has become even busier. Frequently, the queue at the traffic lights extends back to Bishop's Road in spite of some relief from the construction of the New Addenbrookes Road.

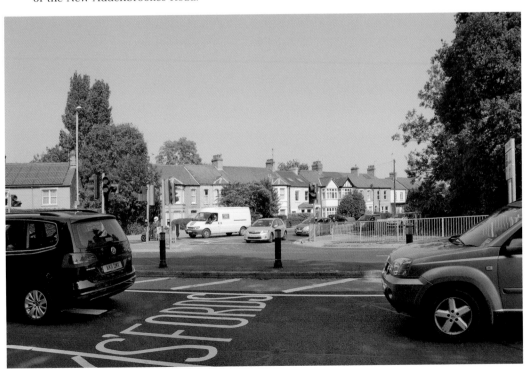

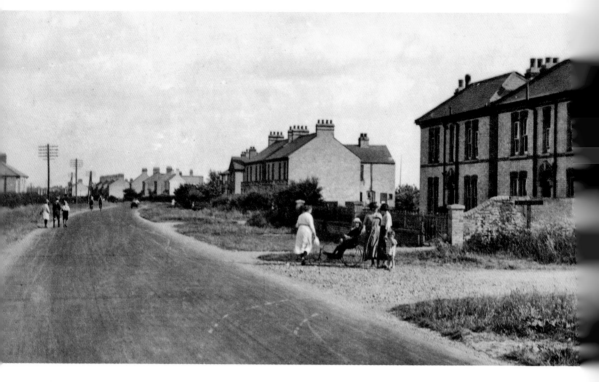

Shelford Road

This 1920s photograph shows the unmade Bishops Road on the right. The gentleman in the wheelchair is almost certainly Willy Pamplin, whose bungalow was built in the garden of the nearest house in this photograph. Willy was a well-known musician. His old tyme dance band played regularly in the village hall and guildhall, and many aspiring musicians went to his house for piano lessons. The picture below dates from 2013.

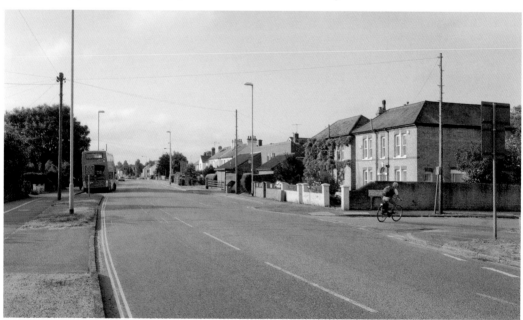

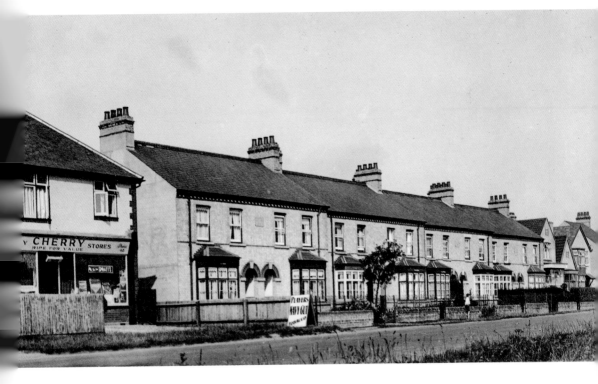

Shelford Road

Cherry's Stores has changed hands many times. In C. J. Pitman's time it was renowned for home-cooked ham on the bone. The houses are still recognisable, but lost their railings to the war effort. Presumably boundary walls have been demolished to facilitate car parking. Four houses have been made into two elegant, substantial town houses.

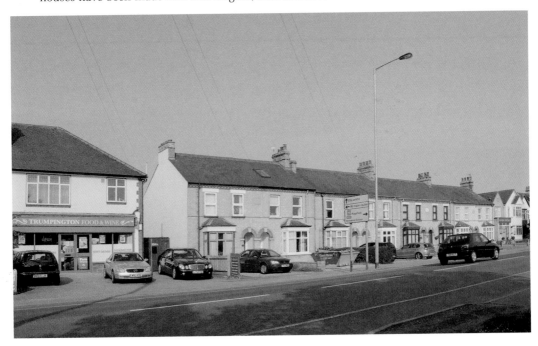

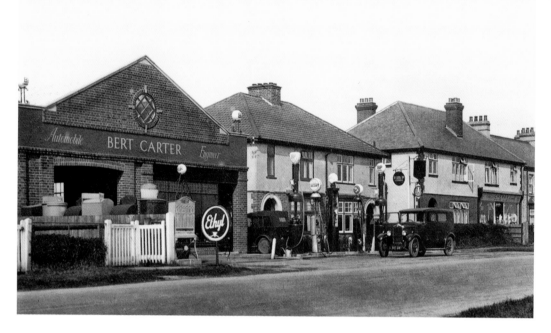

Shelford Road

The garage has seen many changes since Bert Carter supplied petrol, oil and water in the 1930s. In the Second World War, he was licensed to sell petrol. In 1967, Richard Wells demolished the two houses next to the garage to make showrooms and workshops. It became Buckingham and Stanley in 1991.

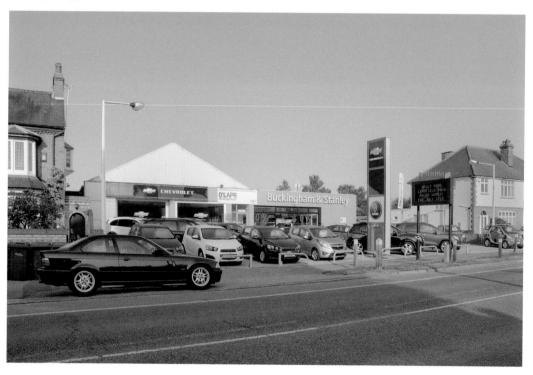

Access Road Casualties

In 2007, houses in Shelford Road were demolished to make way for the Addenbrookes Access Road.

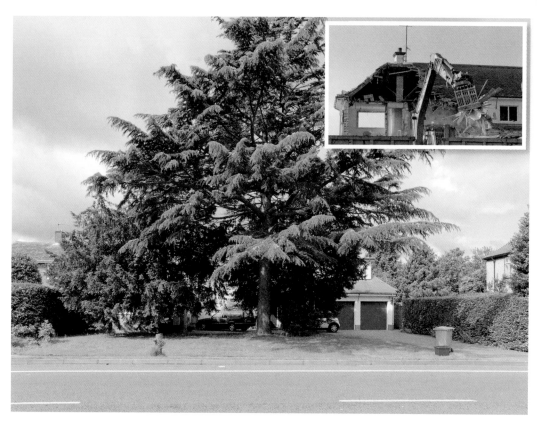

Access Road Casualty

This house, with its beautiful cedar tree, was sacrificed for the road. The inset shows the demolition of the house.

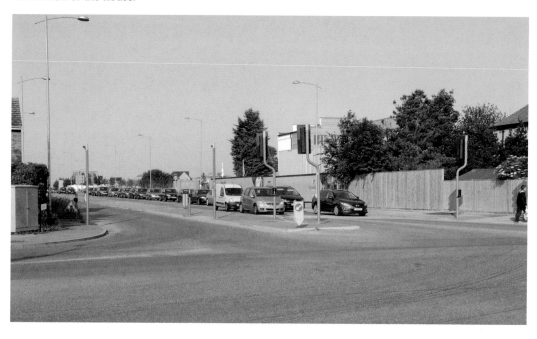

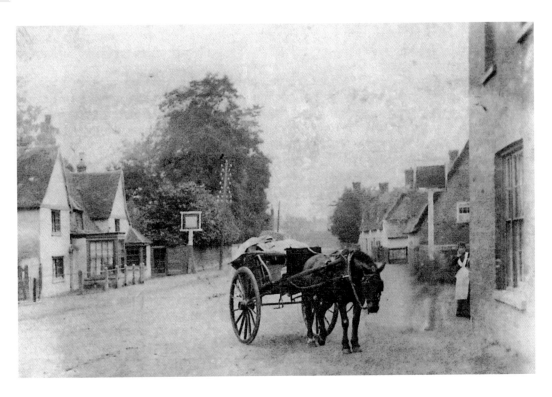

A Shy Maiden

The date of the top photograph is 1893 and the shy maiden is eighteen-year-old Alice, daughter of the landlord, Charles Scott. Wearing his 'other hat', Charles was a builder. The lower photograph shows Mayor Councillor Sheila Stewart as she prepares to 'bow out' at the end of her term of office. In 1893, the pub was the Coach and Horses. Since the late 1990s it has been the Wok and Grill.

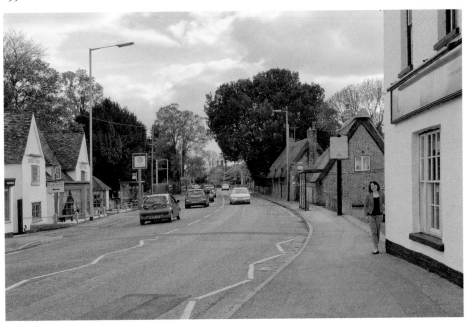

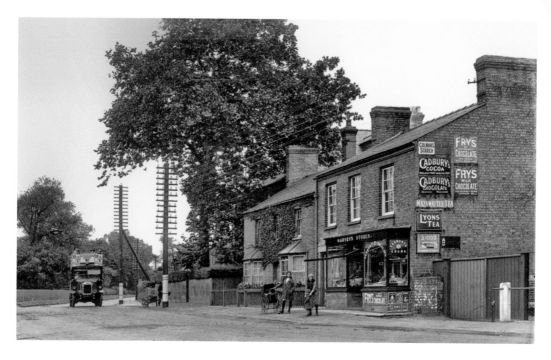

High Street

Harvey's Stores, with its splendid array of advertisements and wide assortment of goods, was succeeded by Truelove's Newsagents. Then came 'Sybil', selling wool, haberdashery and underwear. Next to arrive was the post office. Currently it is 'Granite Transformations'. Next door, Holmlea Hand Laundry is now 'Madarin Stone'. The Ortona Bus Service started in 1909: Cambus now operates the service between Sawston and Cambridge. A bus leaves the park-and-ride site bound for Cambridge, with just four stops *en route*, every ten minutes.

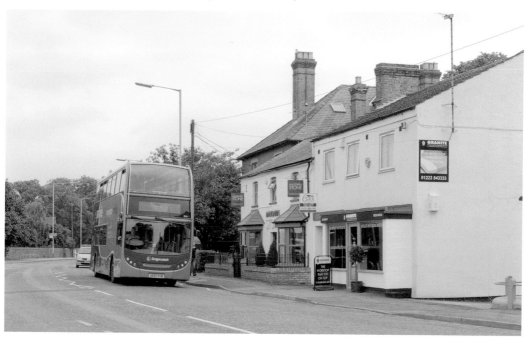

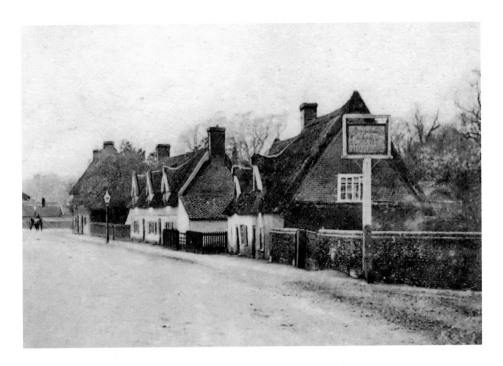

High Street

Three pairs of cottages sit south of the Coach and Horses, now the Wok and Grill. The nearest pair was reduced to a single dwelling following a thatch fire. Recently, extensions have been added and a second detached house is now being built on the site. The other two pairs have been converted to very elegant detached houses complete with modern sanitation. The furthest is no longer thatched. Their gardens were reduced to accommodate Winchmore Drive.

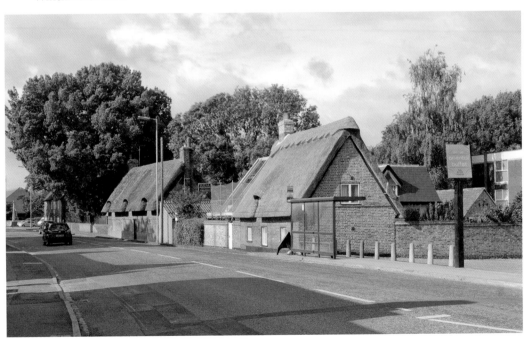

High Street

This is the Back Lane of the Coach and Horses. It did not lead anywhere but was in constant use. Mr Galley, the village carrier, kept his horse and wagon there and it was home to the ferrets belonging to his son Cecil. The cowshed had space for up to twelve cows. All this was demolished to make a way into Winchmore Drive.

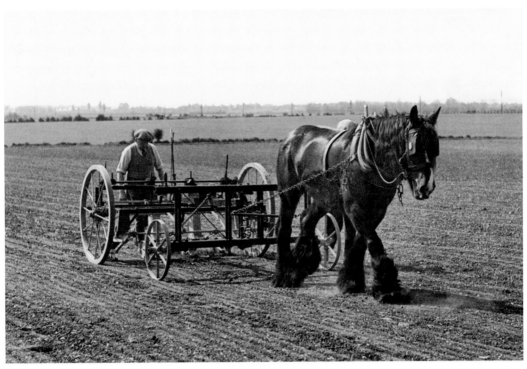

Clay Farm

In the top photograph taken in 1940, Reg Cornwell is drilling Sugar Beet. The drill was designed by Dr H. Martin-Leake and incorporated features that are in use now. Like many such inventions that were so far ahead of the time, the drill was not developed. Fast forward to 2013 and the scene is very different. A spinney has been planted and preparations are being made for building houses.

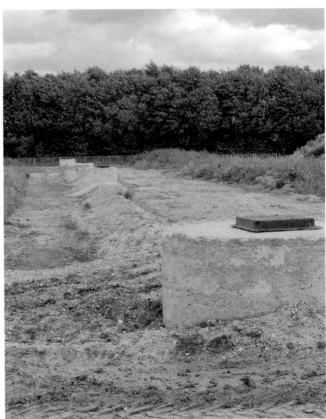

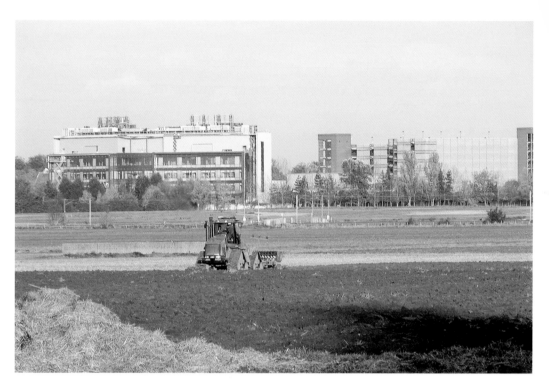

Clay Farm
Autumn ploughing in 2005, and almost the same view in 2013.

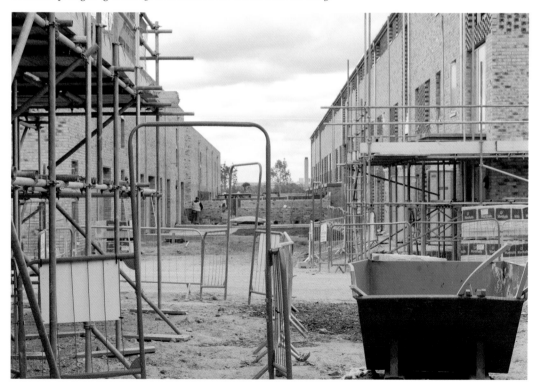

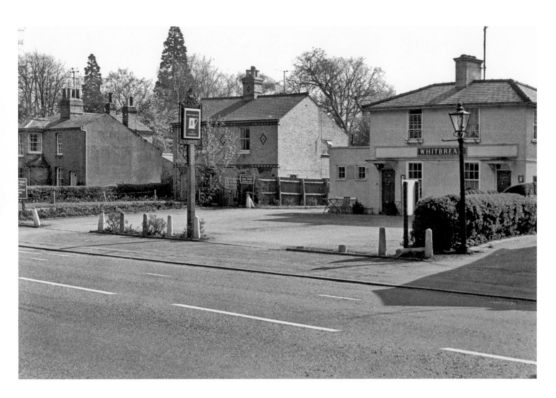

Trumpington Road

The Volunteer in 1969, and in 2013, has seen many changes since the days when it was just a pub. Currently it is a restaurant specialising in Indian food and also offers an excellent takeaway service.

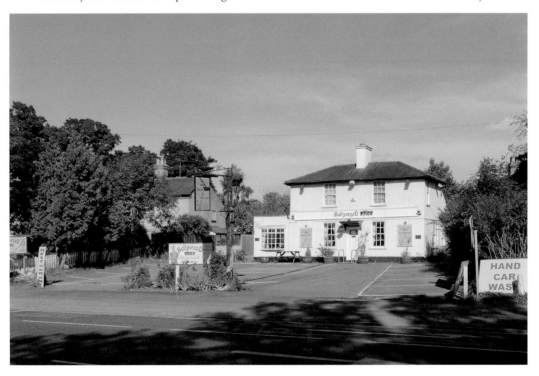

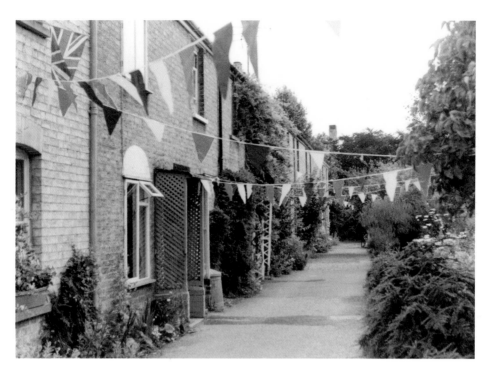

Trumpington Road

Above, North Cottages, decorated for the Queen's Silver Jubilee in 1977, and below, a recent photograph. The pleasant cottages house a close-knit community with a wide range of personalities.

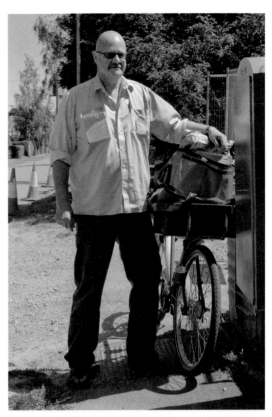

Postman
Today's postman presents a vivid contrast
to the postman with his donkey taken
from the Robinson Collection.

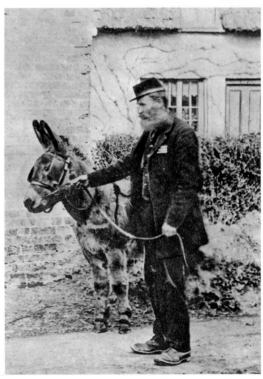

Byron's Pool

Byron's Pool, where Byron reputably swam and where Mr Robinson taught the boys to swim, was a wild and wonderful playground with trees to climb, dens to make and a large field for ball games. A few years ago, it was 'gentrified' with manicured paths and sedate seating. However, nature is gradually taking over. The games field is ideal for hide-and-seek.

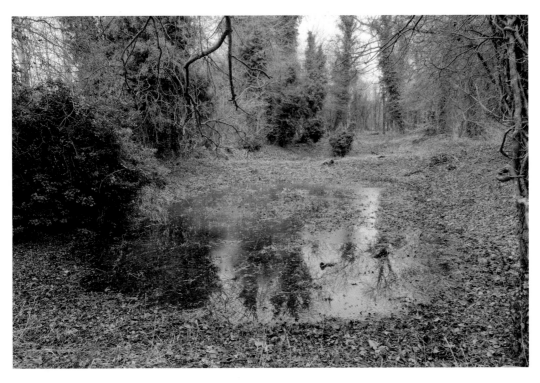

Fish Ponds

In 2010, the ancient fish ponds near to Byron's Pool were in a sad state. The top photograph shows them after clearing scrub and fallen trees. The photograph below shows the cleaning required to remove 'silting'.

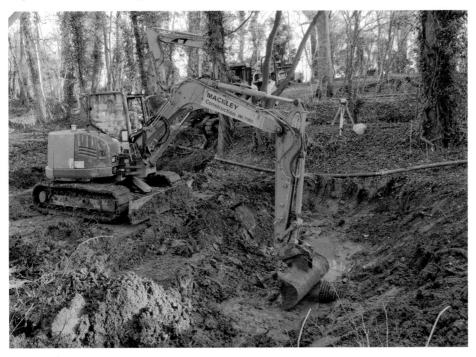

Fish Ponds

The top photograph shows regrowth two years after cleaning. In the photograph below, the opportunity was taken to construct a 'fish ladder' around the weir with a new footbridge over it.

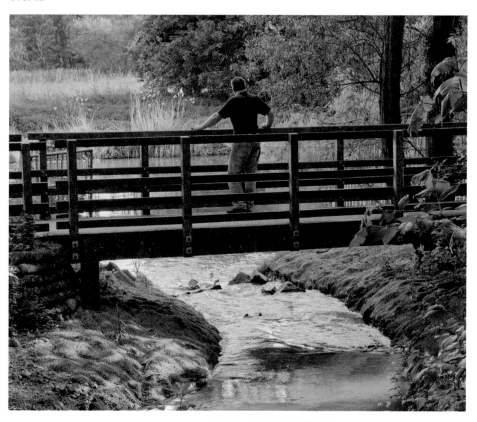

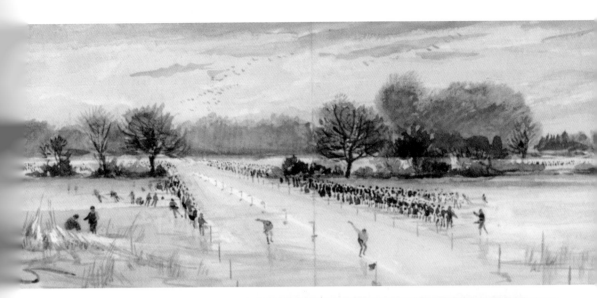

Skaters

This is Lingay (sometimes spelt Lingey) Fen in Grantchester, where the National Ice Skating Championships were held. Costing only one penny, it was a very popular venue for Trumpington families in the 1930s and 1940s, when most of them had their own skates. During the Second World War, evacuees were allowed to skate free – their hosts quickly assumed London identities! This skateboarder, Niall Meehan, does not need a special place.

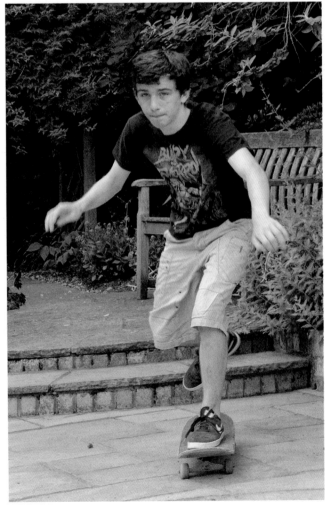

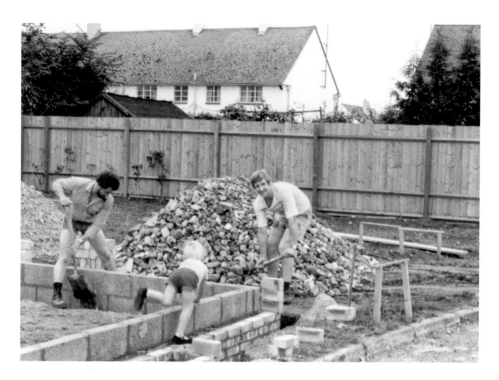

Lingrey Court

In 1982, thirteen men bought a derelict piece of land between Paget Road and Anstey Way. Working thirty hours a week, they completed the first house in 1983. The final house was completed in 1984. Remembering the happy days of their youth, they suggested the name Lingey Close but the nameboard says 'Lingrey Court'.

Shelford Road
Proof that three into one will go – the bungalow was replaced by a two-storey house and two new bungalows.

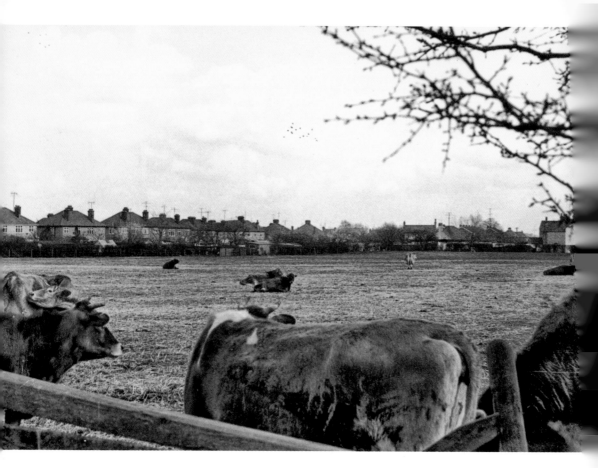

Glebe Farm

Glebe Farm was a successful dairy farm (top plate, 1964). It was also the place to buy fresh-laid eggs and bales of straw for rabbits and guinea pigs, but eventually it all became arable. The bottom photograph was taken from the opposite end of the field and shows the last remains of the dairy and ancillary farm buildings with new cereal silos. Bishops Road appears in both photographs.

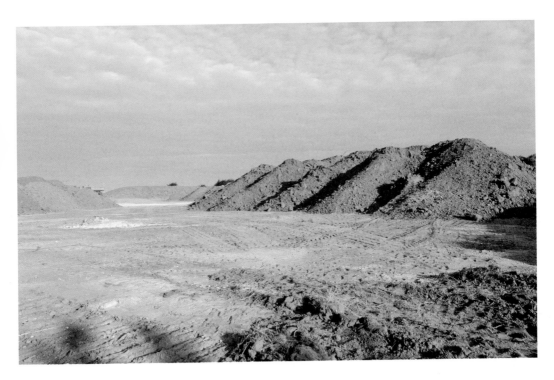

Heaps of Soil

Preliminary investigations prior to the Glebe Farm development revealed there was no need for a full-scale archaeological survey, but it was required on an adjacent field that formed part of the same development. The survey involved moving top soil from one area of the field to the other end. The lower picture, taken from the same spot shows, the first houses to be built with a 'park' in the foreground.

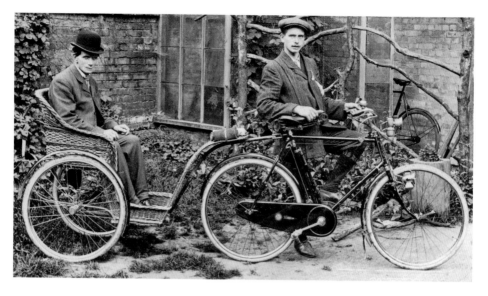

Transport

The top photograph was taken in 1909. The cyclist is Harry Newell and the gentleman in the wheelchair is his father. They were just back from a trip to London. After his father died, Harry would take the 'contraption' to local events and offer rides. Below is Harry's daughter-in-law in today's wheelchair.

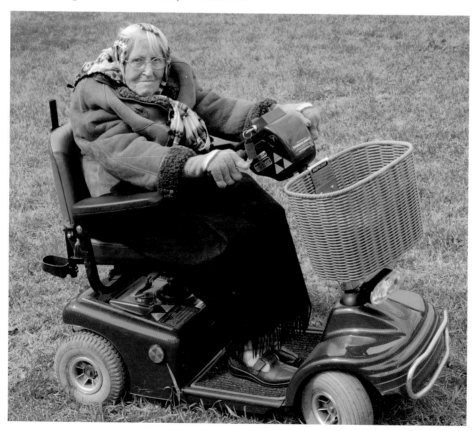

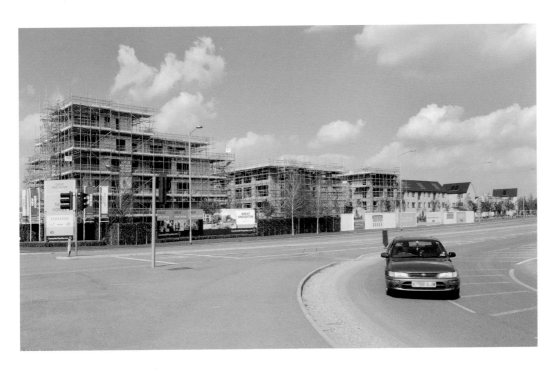

Gateway to Cambridge

There was much discussion about the gateway to Cambridge that falls in Trumpington. There were lots of suggestions and not many people are happy with this 'gateway' from the M11 on the junction of Hauxton Road and the Addenbrooks Access Road. The top photograph dates from May 2013; the lower is from July 2007.

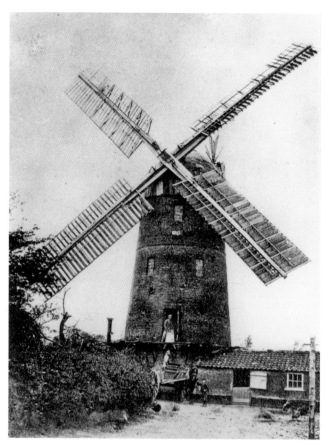

Long Road

The windmill, built in 1812, gave its name to the track beside it – Mill Lane – later changed to Long Road (because it is a long road). The mill house that was never attached to the mill has been a private house for many years, and gained a large garden when the mill and its workers' cottages were demolished. The orangery was built in the space formerly occupied by the mill and cottages.